How to
Photograph
Children

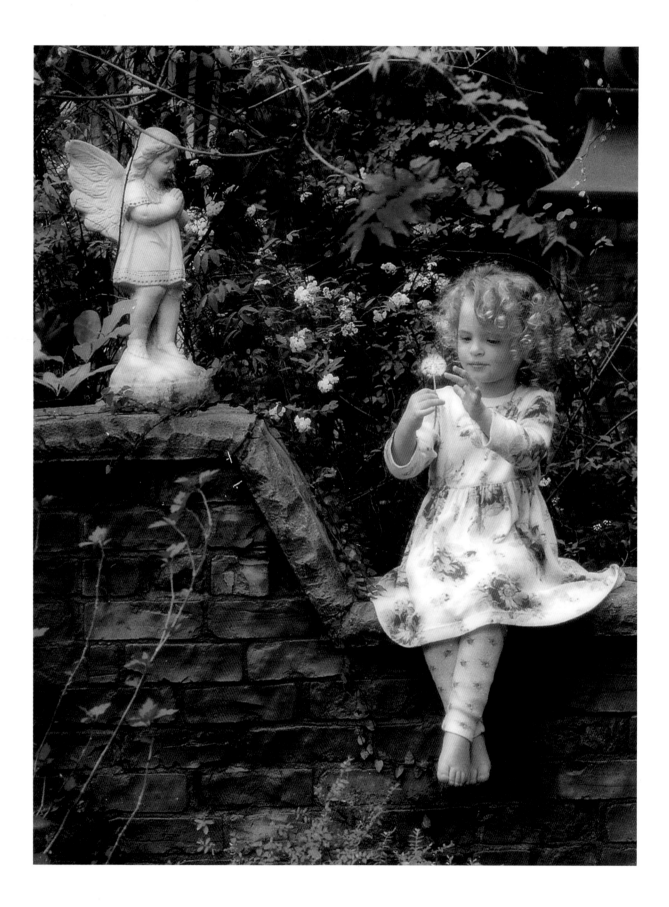

How to Photograph Children

Secrets for

Capturing Childhood's

Magic Moments

Lisa Jane ◆ Rick Staudt

ABBEVILLE PRESS PUBLISHERS

New York London

Contents

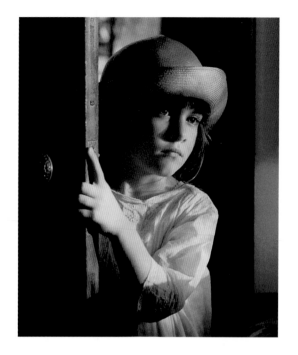

Introduction

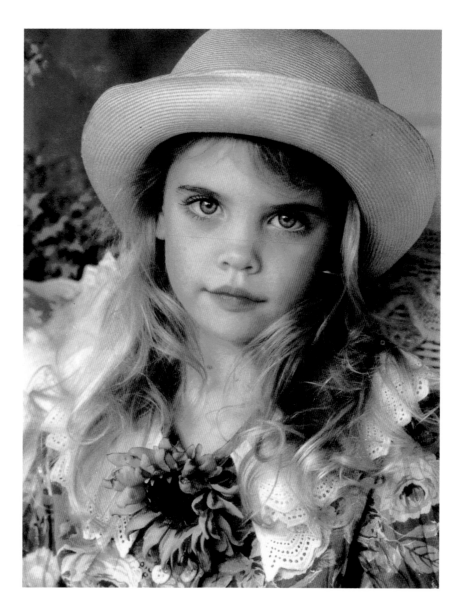

How many times have you eagerly run down to your local photo processor to pick up the pictures you took of the kids playing at the park the day before, only to be sadly disappointed by the results? What went wrong—your camera settings? the film? the time of day? the new technician trainee at your photo lab? Using down-to-earth information and practical, everyday examples, this book will teach you how to make pictures of children with more confidence, consistency, and artistry.

So why another book about how to take a

child's picture? That is exactly the question we asked ourselves when we first considered writing this book. Given our talent and experience as professional photographers, what could we contribute that would really help you take better photographs of children? After researching the current books on the subject, we discovered that many of them tended to concentrate on the mechanical and technical aspects of photography, featuring lots of talk about f-stops, T-grain film technology, reciprocity factors, and such. Other books had lots of pretty pictures but offered little or no advice about how to actually make them. Our intent is to teach you to take superb photos of children with even the simplest of cameras.

We set out to make this book an invaluable guide for the proud new parent with a throwaway camera, for the serious amateur with a sophisticated 35 mm SLR camera, and even for a budding professional. We have designed it not only to help you create beautiful, well-thought-out portraits of children but also to make the best of your quick snapshots. Our book is full of beautiful pictures of children of all ages, both individually and in groups, with simple, down-to-earth explanations of how those pictures were composed and how they were taken. We focus on children here, but our techniques and ideas can be carried over into all sorts of photography.

Because technical knowledge is the cornerstone of artistic expression, we begin by presenting a solid foundation of essential technical knowledge, along with practical everyday tips for photographers at any level of skill. You do need to know which tools to use and how and when to use them; you also need a basic understanding of composition and design. With the practical information you will learn from this book combined with your own practice and experience, your camera

Fancy lighting equipment isn't a necessity. The simple window light in this picture adds to its warmth and charm.

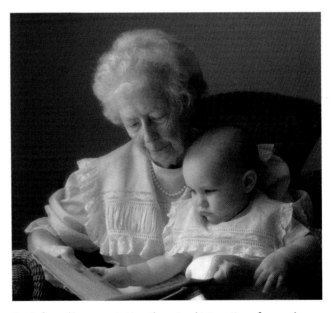

Don't force the moment. Here the natural interaction of a grandmother and her grandson creates a loving portrait.

Let the child be natural and spontaneous, rather than insisting on a formal pose.

ple's children. Just keep the following in mind, and you will be moving toward becoming a successful photographer of children—whether your own or someone else's. Always be mindful of how meaningful your photographs are today and will be tomorrow. What this book will teach you is how to create precious memories of childhood. You can make a simple record shot with dull lighting and an unflattering pose, or you can create a wonderfully personal interpretation that captures the spirit of the child. Both images have sentimental value and would probably be the first things that parents would grab to save from a fire or flood. But the images that make you feel something deep inside your heart about some wonderful aspect of a child's character when he was oh so little . . . those priceless images are the ones we want to help you make.

Who Are We?

We first met in 1987 as fellow members of the Professional Photographers Guild of Houston. Today our studios are just down the road from each other, and we are both award-winning photographers specializing in fine portraits of children, with over thirty years of combined experience. We take great enjoyment in speaking to groups of professional photographers around the world and in helping them improve their creative and technical skills in children's portraiture. As parents ourselves, we understand the enduring significance of children's portraits and sincerely hope that this book will enable you to experience the great joy of creating beautiful photographs of the children in your life.

When you decide to make a picture, you have two choices. You can either grab your camera, aim, and shoot. Or you can take a moment to think about the situation and determine how to make

will soon begin to feel like a natural extension of your hand and mind. Once you reach that heady level, freed from having to worry about technical decisions all the time, we will share with you how to create a truly personal portrait of a child in your own distinctive style. You will soon experience the wonderful feeling, shared by all children's photographers, of knowing that you have preserved a special moment of a childhood, to be cherished for a lifetime.

Maybe you are about to give birth to your first child or are awaiting a new grandchild. Maybe you want to learn to take better pictures of other peo-

your picture more creative. We will help you make the following choices:

+ Where should I photograph the child, and how do I place her in the scene to make the most effective composition?

+ What props could the child play with in order to tell a story about some aspect of his life?

+ Is the available lighting flattering, or do I need to help it out a little?

+ What can my current camera do for me, and do I really need a better one?

+ Where do I position the camera—high or low? horizontal or vertical? close up or full length?

There's no better prop to help tell a child's story than his favorite toy or outfit.

+ How do I adjust all those settings on my camera to obtain the best exposure? And what film am I supposed to be using?

+ How can I help a child give me the perfect, natural expression I need to make a memorable portrait?

Sometimes you will have enough time to consider some or all of these factors before you take your picture. In fact, the planning stage is often just as much fun as the actual picture taking. At other times, a situation will surprise you, and you'll have to pick up your camera and do the best you can at a moment's notice. At times like that you simply allow your instincts to take over, and that's when experience really pays off.

Don't let the above list intimidate you into giving up before you start. We will gently hold your hand and walk you step-by-step down the path of discovering children's photography, and most important, we'll help you to have fun through the entire journey.

I. Composing Memorable Pictures

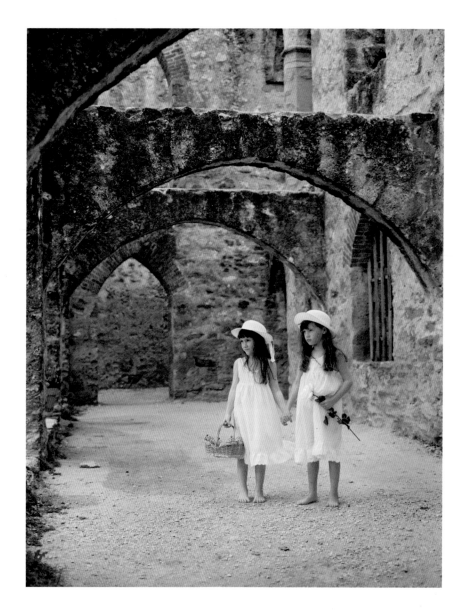

With just a little understanding of the basics of composition, lighting, perspective, posing, and color, you will immediately start taking better pictures. This chapter will guide you step-by-step through the basics of composition and posing, with numerous sample photographs to illustrate all the key points. We refer primarily to photographing children, but you will discover that the following ideas are equally useful whether you want to photograph a child, an adult, a pony, or a sunset. Have no fear—with a bit of practice, composition is easy to get a feel for, especially if you

take the time to study your resulting pictures. We will share with you the things we think about even before loading the camera and all the way through the process of creating the picture.

Composition

Key to any successful work of art is composition. Every time we point our camera at a subject and take a picture, we make several decisions, whether we do so consciously or not. We have to decide what part of the scene in front of us should be included and what part should be left out. Should we zoom in close or capture the whole scene? Will the picture work better taken as a vertical or a horizontal? Of course, some pictures are not worth all that much thought, and sometimes you can think so long about the composition that you miss the picture completely. But when it comes time to photograph important moments and memories, the ideas you learn from this chapter will be your best friends.

Over the centuries, masters of art have identified certain principles of design and composition that are still taught to artists and graphic designers today. We will show you not only the basics of how

Triangular compositions have long been favored by artists, for they give a feeling of balance and stability. A stick was thrown in the water to focus the dog's attention.

to use these universal principles to your advantage, but also how to break them occasionally in order to create a truly original photograph. (But you still need to understand them before you break them.) At this point you might be tempted to flip ahead to some of the later chapters and check out all the creative and entertaining ideas we will be sharing with you, which is absolutely fine. But at some point, come back and study this chapter until every point makes sense to you. This basic knowledge will help you solve any photographic problems you might encounter.

Portrait Studies vs. the Environmental Approach

For the purposes of this book, we will divide pictures of children into two broad categories: "portraits" and "environmentals." In general, both types require a little time and thought before taking the picture. They differ from a snapshot taken spur-of-the-moment to capture something cute or silly.

♦ A *portrait* is a picture taken close up that primarily features the child or children, with the setting and background only secondary in importance.

♦ *Environmentals* are pictures in which the child is placed into a setting that becomes a dominant element in the photograph.

Both types are wonderful expressions of childhood, and it's worth deciding which approach you want to take before you click the shutter.

Portraits

Portraits, or close-ups, are what most of us are used to taking. Parents, in particular, tend to ask their children to look up at the camera and smile, thinking they are taking a portrait. If you remember nothing else from this book, just remember

this: Move in closer! Most children's portraits are taken from much too far away. By coming in closer on the child, you can capture nuances of expression while at the same time eliminating meaningless distractions. You can come in closer either by using your zoom lens or by being a "human zoom" and just walking up. Close-up portraits are probably the hardest pictures to do really well because when you move in close, the child almost inevitably becomes aware of the camera, making it more difficult to capture a truly candid moment.

When taking a portrait of a child or group of children, you want to focus on the faces while playing down other elements. How do you do that? First of all, you can select a background that doesn't have any bright, contrasty elements fighting for our attention. You can dress the children in simple, timeless clothes that are not too busy or trendy and that won't look dated in a few years. It is also advantageous to have a zoom lens

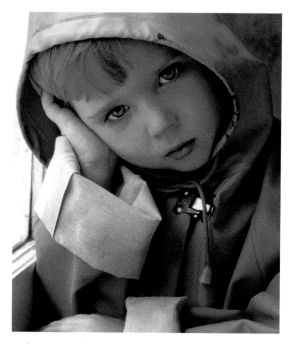

In this portrait, the emphasis is on the child, not the setting.

35 mm

100 mm

200 mm

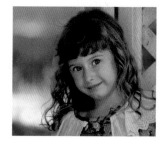

300 mm

This sequence shows the different results you can get by using a range of lens lengths while shooting from the same camera position.

that extends out to the 80 mm–105 mm focal-length range or longer. Coming in close with a short telephoto lens like this has two benefits. The background automatically blurs out of focus, which directs attention back to the child's face. This technique is referred to as selective focus. It also avoids distorting the face, which would be a problem if you came in close with a wide-angle lens. Television studios, for example, are usually small spaces in which the camera operators are forced to work with wide-angle lenses. That's why people often look ten pounds heavier on television than in person.

Environmentals

An environmental, as opposed to a portrait, gives almost as much importance to the setting as to the child. It is a wonderful way to tell a story in pictures. Look at almost any Norman Rockwell painting, for instance. Surrounding the young girl and

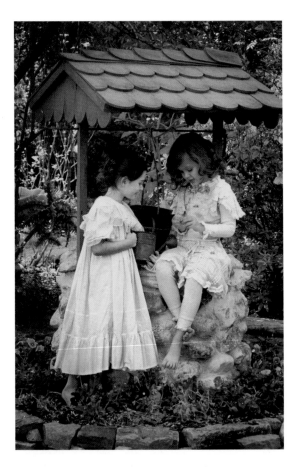

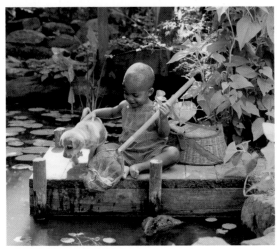

In environmental images, such as these, the background is a dominant element.

her kitten or the Boy Scout with his little brother will be several elements that tell you so much about the children that you instantly feel as though you know them.

A great environmental photograph of a little boy might feature him fishing by a pond. He could be using his grandpa's old bamboo fishing pole and wearing his dad's favorite cap. His puppy might be lying obediently by his side, and his new bike could be seen leaning against the old pecan tree a few feet behind him. Is he looking up at the camera and saying "Cheeeese!"? In an environmental image, probably not. Maybe he is reading a book about fish, looking at the cork bobbing in the water, or taking a nap by the bank while the pole is being bent over double by the huge fish he's dreaming about. Your imagination is the only limit on the wonderful stories you can tell with your camera and a roll of film!

Horizontal vs. Vertical Compositions

Take a good long look at your camera. Double-check the owner's manual. Is there a "horizontal hold" feature? Doubtful. We see so many pictures of a standing child taken horizontally with all sorts of distracting clutter on either side, when a tighter vertical composition would have filled the frame with a much cleaner and more interesting image. Some people just can't bring themselves to turn the camera sideways and make a vertical picture.

Portraits of individual children, seated or standing, are often best taken vertically. This is usually the most effective format for coming in close enough to position the children prominently while eliminating distractions. Usually, the closer you come in, the better—assuming you are not trying to capture some interesting element in the background. Conversely, a child lying on her side is often best photographed horizontally, as are

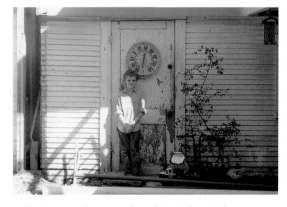

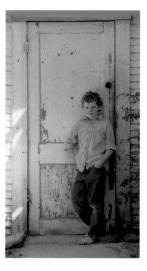

In the horizontal version, the subject is lost in the clutter. Eliminating the background distractions and repositioning the camera for a vertical view puts the focus back on the child.

most groups of children. Vertical pictures tend to feel more formal. Vertical is upright, strong, erect. Horizontal pictures tend to seem softer and more casual. Again, these are only general rules, and you have our full permission to go out there and break them. Just be sure you know why you are doing it.

A Single Center of Interest

Most great images lead the viewer to a single point of primary interest. Leonardo da Vinci was a master of this principle. When you look at his *Mona Lisa*, for example, your attention is immediately drawn to her eyes and enigmatic expression. Study his *Last Supper* and you'll see that even with the many storytelling elements placed throughout the image, your eyes are still directed straight to the central figure of Jesus. Why is this so? Leonardo placed him in a powerful position within the composition, framed by an open door that singles him out from everything else in the painting. Many of the apostles reinforce this emphasis by looking at or pointing to him. All of these elements help make Jesus the single center of interest in what otherwise could have been a very confusing composition.

Assuming you are photographing one child,

try to center everything in the picture on that child. If you notice any clutter in the frame that will distract attention from the child, take the time to remove it. Such simple attention to detail is often what distinguishes a terrific picture from a mediocre one.

So, you're making a picture of a group of children and you're worrying to yourself, "Hmm, there's more than one center of attention here." Easy—just pose them so close together that everyone's touching. Alternatively, give them a fun activity to do together, and suddenly you'll have

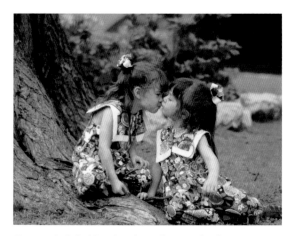

Showing kids holding hands or sharing a book, a pet, or even a quick smooch is a great way to combine individuals into a cohesive group.

Not only are there far too many distractions in this cluttered photograph, but there is also a pole growing out of the girl's head and it looks as though she has only one leg.

This is a far more pleasing composition, with the attention directed to her beautiful face and the surroundings reduced to a minimum.

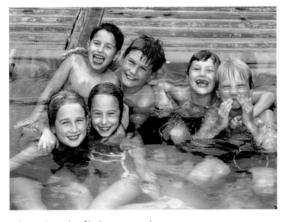

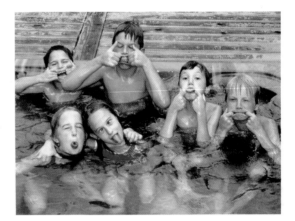

When a bunch of kids get together, you can compose them into a group, but you can't always make them smile for the camera.

condensed a random bunch of children into one center of interest . . . a group. The first key to great group shots is achieving color harmony in what the kids are wearing. The second key is to have them all looking at the camera, at each other, or at the same focus of attention. You may start hearing shouts of "Becky, stop touching me!" and "Mommy, Mac put a frog in my boot!"— which are often closely followed by Becky's bopping Mac with her doll. We will be covering this topic in our next book, *Photographing Children: Mission Impossible.*

Placing the Child in the Picture

One way to make your subject really stand out is by knowing where to place the child in the frame. We will offer some suggestions and general rules about placement, but the final decision will come from your own heart. You could reason that placing a child smack in the center of the picture would focus all the attention on him, and that might be so. The problem is that the child can look sort of trapped, with nowhere to move, resulting in a picture that seems boring and stagnant. An effective rule of thumb is to place the child a little bit off center, about a third of the way in from the top

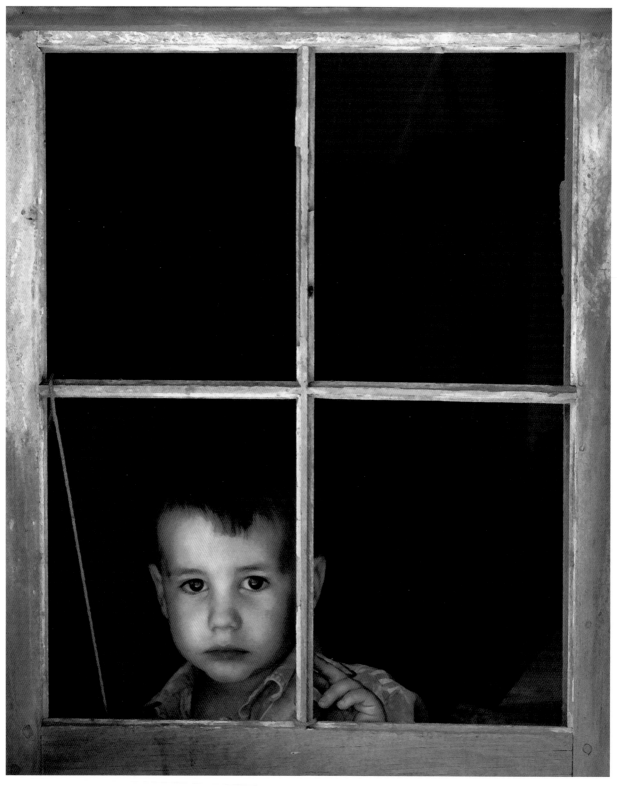

You can find frames all around you that will help
concentrate attention on the child.

or bottom and from the left or right edge. This is called the rule of thirds, and it is the most powerful and most pervasive rule of art composition ever devised.

Off-center placement of children tends to result in a more exciting composition, implying action and giving the subject a place to be and a direction to go. When executed well, placement of a child off center can make a dramatic statement. But if you exaggerate the effect too much, it can also look as though you were falling down a hill when you snapped the shutter!

The compositional mistake we see time and again is when Grandma takes direct aim at the child's face, placing it right in the center of the frame. What she ends up with is a child's face connected to part of a body below, with the top half of the picture a vast wasted space. This makes the child seem very small and insignificant. By positioning that same child's head about a third of the way from the top of the picture and moving in

Below: In this horizontal snapshot of a seated little boy from a standing position, the child's head is at dead center and surrounded by distractions.

Right: To get a more pleasing effect, take a few steps forward. Drop to one knee to get on the child's level. Shift to a vertical composition to eliminate distractions and follow the "rule of thirds" to position the child's face.

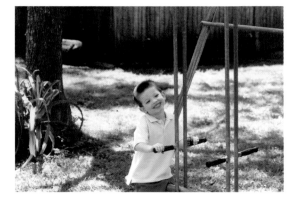

closer, Grandma will create a far better portrait and waste much less space. When using an auto-focus camera, just be sure to use those little focus marks in the center of your viewfinder to focus on the child's face, then move the camera down or to the side to achieve a more exciting photo.

Often a frame within a frame can be found or created in a setting, and that makes a very effective device for focusing interest on a child. A good example might be photographing a child through an open window or door frame. Your eyes naturally move through the frame and onto the child. It certainly worked for Leonardo! Spend a pretty summer day with your child looking for frames,

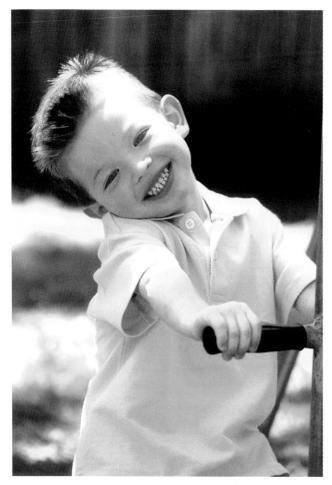

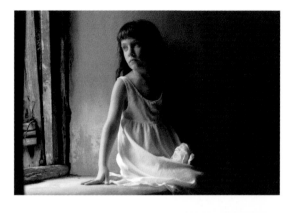

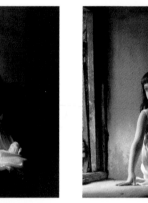

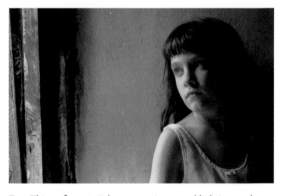

Top: This soft portrait has evocative mood lighting and a beautiful expression, but the girl's placement in the center of the image could be improved.

Center left: Using a vertical crop to lower her within the picture is better, making her seem smaller and more lost in thought, but she still seems too centered.

Center right: Placing her in a low corner intensifies the sense of rainy day melancholy.

Bottom: Try some unusual crops. Break the rules. Is this an effective composition or a big waste of space? It's your call!

natural and man-made, to use in composing some great pictures. Frames can be made up of hats, scarves, tree limbs, your limbs, or any number of other things.

Crop Till You Drop

Cropping just means determining the edges of your picture. Effective cropping will focus attention on what is important in your pictures and do away with distractions. Whether you are cropping in the camera as you shoot or having your photofinisher print only a portion of your negative, there are some basic rules you should be aware of before lopping off the edges of your pictures.

Generally, avoid cropping any human or animal at body joints such as elbows and ankles; otherwise, your subject may look like an amputee. When you want or need to crop into someone's body, place the fleshy part of an arm or leg at the edge of the frame. Cropping in tightly on a subject, particularly the face, produces an intimate and direct portrait that will always command attention, being literally "in your face." If you are photographing a child or a group full length, try to leave more space above their heads than below their feet. When you see a print of someone with little space above and lots of ground below, he often seems to be floating in space rather than firmly grounded. It simply follows nature that we have more space above us than below—in fact, common rules of composition often have a basis in the laws of nature.

A great way to teach yourself about cropping is to put your picture down on a table and, with two L-shaped pieces of paper, play with the framing until it looks just right to you. This is also a useful way to practice your in-camera framing skills for when you are out there making new pic-

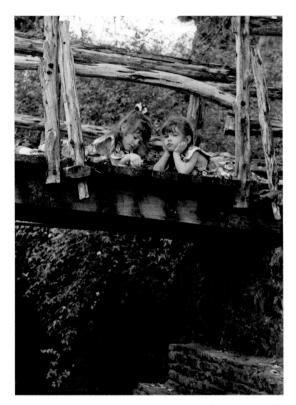

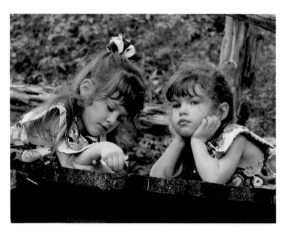

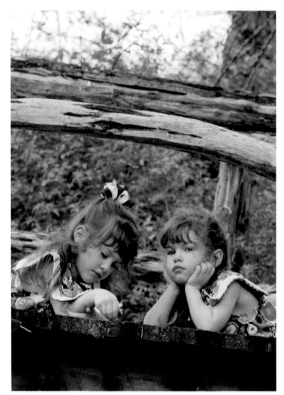

This is the original, uncropped image, which was intended to be an environmental portrait. Notice how the faces are framed within the structure of the bridge to direct your attention to them. Let's look at some other possible crops.

Top right: In this more intimate close-up portrait, attention shifts from the setting to the girls' pensive moods.

Right: With a vertical crop, the railing above the children becomes a distracting feature in the composition, and they seem trapped beneath its weight

Below: A dramatic 4 x 10 in. panoramic crop emphasizes the horizontal line of the bridge.

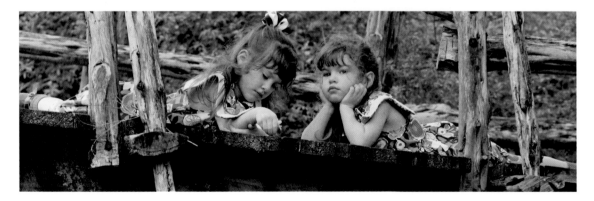

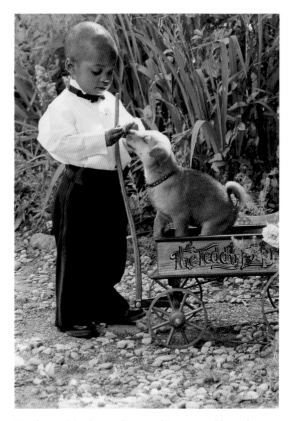

No photo with a boy and puppy this cute could ever be called bad, but the composition above could be improved. At the right, with more space above his head and less under his feet, he looks more grounded and at ease within the space.

tures. Have fun with this process and don't be afraid to try something crazy now and then.

Pick Your Best Angle

Some photographers, often the same ones who shoot only horizontally, develop the lazy habit of taking every picture from a standing position. What happens when this person is taking pictures of children? The children are forced to look up at the camera, which forces the viewer of the picture to look down on them. Who enjoys being looked down on all the time? It is a weak position in which to find yourself . . . distant, small, and remote. It can be a fun angle if you want to catch a picture of, say, a child covered in chocolate with his hands in the cookie jar, but normally it is not

the most flattering or interesting position from which to shoot.

Drop right down to your knees, or even lie down if necessary, and photograph children eye to eye. It's more fun for everybody involved, and you get the opportunity to reveal the world from a child's perspective. In the studio we often kick off our shoes and just sit and play games or read a book or maybe put together a puzzle with the children and their parents while in the process of making great pictures. It's a wonderful way to get a sense of a child's personality while at the same time gaining her trust and confidence.

On the other hand, aiming the camera up at someone forces him to look down his nose at the viewer. This can be very effective at times. Maybe

Though it takes more effort, it's almost always more effective to photograph children from their own level.

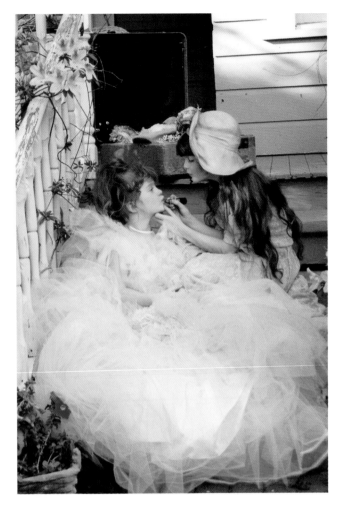

you are photographing a little boy as a rough, tough cowboy and want to make him look big and tall in the saddle. Shooting up at him from a low camera angle would be a perfect way to make a strong vertical composition. Again, as long as you understand the rules and how they work, you are free to use them to your benefit.

It makes good sense to walk a complete circle around the child, looking for the best point of view. That might come in the form of prettier lighting on the child's face or fewer distractions in the background. In any case, it is often worth the effort, if the situation allows you to take the extra time.

Take a new look at the world around you and think about the simple compositional rules we have been talking about. Look at the images you see in magazines, movies, and on TV. Think about the spacing and cropping around the subjects. Think about the camera angles and compositional elements. One of the most valuable educational exercises is just to look at professional photographs that companies have paid piles of money for and think about why the photographer composed and photographed the image the way he did. Why pick that setting and those props? Why use the composition, camera angle, or selective focus in that particular way to draw attention to the main

subject? Sooner or later, you will turn into your own art critic, and your own pictures will benefit from the experience.

Color

Color is a very important emotional stimulus. Don't be surprised to find dozens of books in the library discussing nothing but color theory. You can learn all about color perception, light transmission and reflectivity, and spectral analysis. For our purposes, all we need to understand is the psychology of color—how certain colors make us feel and how these feelings can improve our pictures.

The colors we wear and the colors of our automobiles speak volumes about our individual personalities. Hot colors like reds, oranges, and

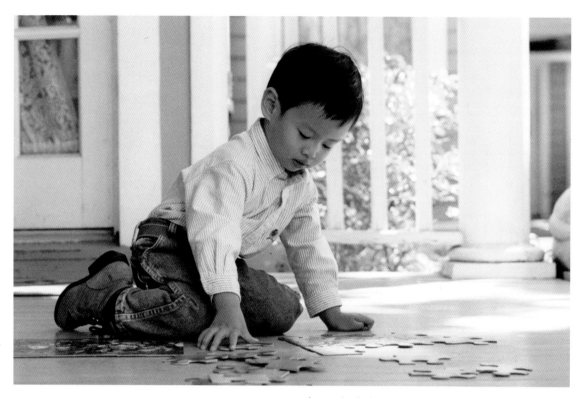

Above: This little boy loves putting puzzles together. Allowing him to have fun and be himself led to this sensitive, storytelling portrait.

Left: A typical snapshot taken from adult height, looking down on the child.

Below: Using a wider-angle lens and shooting from a dramatically low angle gives this portrait a feeling of motion and power.

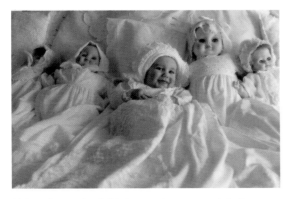

Light colors and soft fabrics are always a good choice when photographing infants.

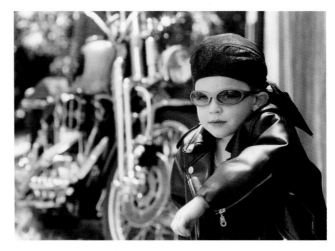

Black isn't usually a color for kids, but here it becomes a strong elements of this storytelling image. A 300 mm tele-photo lens was used with low camera placement to make the four-year-old look big and bad while forcing the Harley out of focus.

yellows are flashy and attention grabbing. When we "see red," we sense danger or excitement, so we immediately stop and look intently. Red is the color of blood, a stop sign, a hot Ferrari. Cool colors like blues and greens are gentle and passive, generally blending into the background.

You are wise to think about color whenever you try to make a picture you want to be more than just a snapshot. Again, a snapshot is made by grabbing the camera and recording a picture of something that is already there; we typically exert very little control over a quick snapshot, though with luck a great expression on a child's face can turn an ordinary snapshot into a priceless memory. We want you to move beyond snapshots and learn to create consistently pleasing pictures by learning to take control. This means taking control both of your equipment and of the elements in the scene and using them to make your own personal expression of the essence of childhood. And color is one of the most important elements you have in your creative palette.

When taking portraits of an infant, we generally stay with pastels and whites. Light colors suggest an innocence and a soft, almost angelic feeling that would be all but impossible to capture with vivid or deep colors. We often think of babies

as a gift from heaven, and that is the feeling we like to convey with the use of light colors and simple, soft cloudlike fabrics.

When taking a picture of a five-year-old boy posed in front of Dad's Harley Davidson, lean toward using masculine colors, including black. When selecting his clothes, pick something that not only looks cool and tough but, even better, has colors that complement those of the bike and whatever other background elements you have selected. In other words, consider the color harmony in the scene.

Try to keep clothing as simple as possible. If you make pictures of children wearing clothing full of bold patterns, you will often see the clothes before you see the child. On the other hand, if Grandma hand-embroidered a big red tractor on the front of your child's overalls, that gift of love will be more important in making a picture of him for her than the rule of keeping it simple. Remember, know the rules, understand why they are there, and don't be afraid to break them.

With such an overabundance of colors and patterns, it's often hard to find the center if interest.

Working with Children

This seems to be the easy part for lots of adults and the hardest for others. Maybe the best way to create great children's photographs is just to let out the child inside yourself and give him or her permission to go play.

Here is an exercise in frustration. Take a normal, energetic, curious two-year-old boy. Dress him up in an uncomfortable suit with a tight bow tie and make him sit in a stiff, uncomfortable chair. Wait till just before nap time. Now, with your camera on a tripod and all of your props just right, coax him through a dozen or so stiff, formal poses with the hands, feet, and head positioned exactly, perfectly right. Don't forget to fiddle with his clothes and hair all the time, while, of course, getting the perfect expression from him on each shot. In other words, try to exert complete control over this poor child while asking him to be his natural self so you can capture his true personality. It's safe to say that you are playing a losing game while at the same time teaching this child how unpleasant it is to have his picture taken. Instead, make photography a fun and comfortable experience for

children. We all have to be photographed many times as we go through life, and the fear of being photographed can become real—a fear that almost always starts during childhood.

What is the alternative? Why not just let him be a two-year-old? If he's your own child, you already know what makes him happy and at what time of day he is usually active and energetic. Take advantage of that knowledge and let it work in your favor. If he is not your child, talk to his parents. If you are not currently up on two-year-old boys, spend some time with him and try learning more about him. Give him some of his favorite things to play with. Let him be himself and do his own thing. Use what you learn in this book to capture his spirit, his sense of wonder, and everything else that makes him unique. One of our very favorite compliments in the studio is when parents thank us for catching a certain familiar feeling or expression that they cherish in their child.

Putting a child into a fun situation does not mean that you should abdicate control of the photo session. You can still determine what the child is wearing, eliminate distractions in the background, and place him in an appropriate setting. But once all of the artistic and compositional pieces are in place, just sit down and have some fun, taking pictures all the while. Not only will you be more successful, but he will also learn that a camera is not a big black scary box to fear for the rest of his life.

The child does not have to be looking into the camera the whole time you are having fun together. How can he have any fun doing that. But after you have a few great pictures of the child playing, reading, petting the puppy, or whatever, and just as he is smiling happily, you can ask him to look up (or better, just make a funny noise to regain his attention), and then catch that lovable little face!

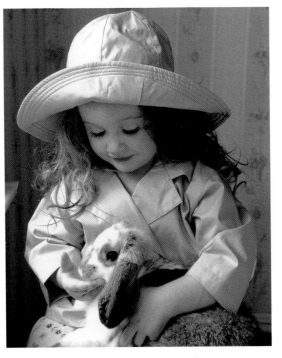

Left to their own devices, and given something interesting to do, kids often create their own best poses.

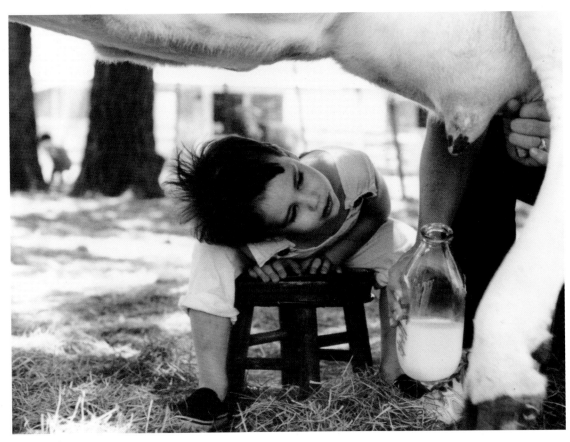

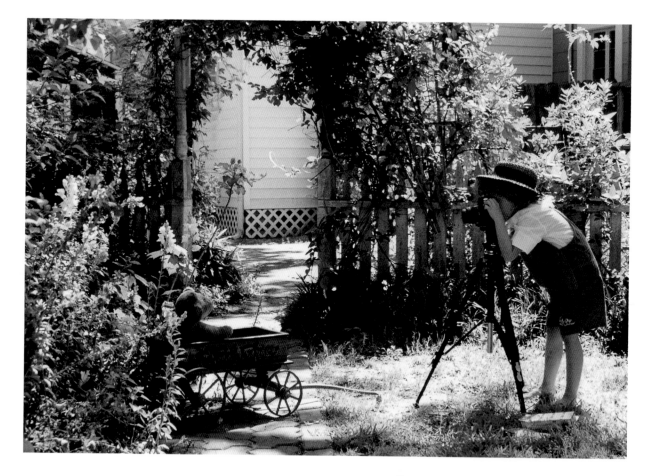

Let the children become participants in the photographic process. When they are old enough, sit down together over a root beer and talk about what they think would make a neat picture. Talk about their pets and activities, their favorite clothes, and other things they like—their input will result in a more enjoyable experience for all involved. You can use their silliest ideas to photograph them, and then learn together what works and what does not. You might even let them photograph you for a change. What a great way of getting closer to your children, investing time in them and creating lasting memories together!

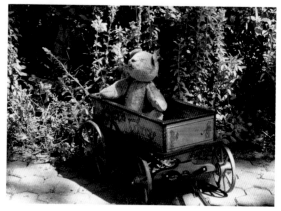

Use your photographs not only to record changes in a child's appearance but also as a record of her changing personality and interests—as in this image of a budding photographer and her own picture of a favorite teddy bear.

If You Want to . . .

Create a Portrait Study Move in closer to the child, eliminating any meaning-less and distracting elements.

Take an Environmental Place the child in a setting that helps her relax and perhaps tells a story about her, then back away far enough to include the surroundings. Perhaps add a few storytelling props to make the scene even more meaningful.

Eliminate Distractions Try holding your camera first horizontally and then vertically to see which composition reveals the most good stuff and eliminates the most bad stuff. Also, try squatting down low, standing on a chair, and moving to different angles to find the best view. There is almost always a better angle to be found.

Compose the Image Place the child where he will be the center of attention. The exact center of the picture is usually not the most interesting place to put the child (though it can be).

Choose Colors Hot colors convey excitement, danger, happiness, and in general grab our attention most quickly. Cool colors suggest peacefulness and serenity while calming our emotions.

Pick Clothing Clothing for a portrait should generally be classic and simple, so that it doesn't compete with the child's face for attention. (There are many creative exceptions to this rule.)

2. Let There Be Light

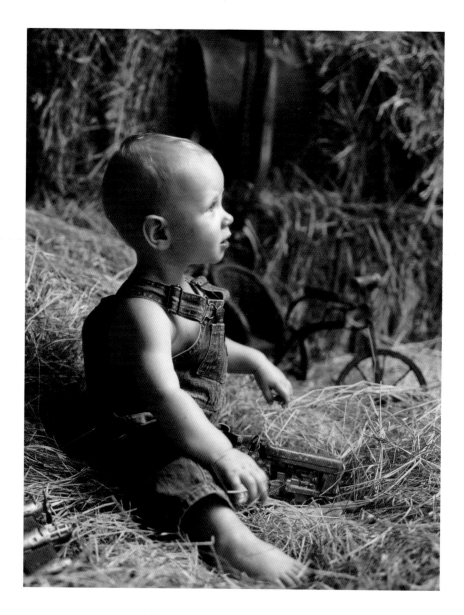

The word *photography* is derived from the Latin *photo*, meaning light, and *graph*, meaning draw. So photography literally means drawing with light. Often we discover that the lighting in a photograph is as important as the subject, if not more so. Think about the Grand Canyon for a mo-ment. Have you ever seen a photograph of it taken during the middle of the day? Sure, and it just looks like a big hole in the ground. But have you seen photos taken at sunrise or sunset? Breathtaking reds and oranges with deep penetrating shadows paint a completely different mood and feeling.

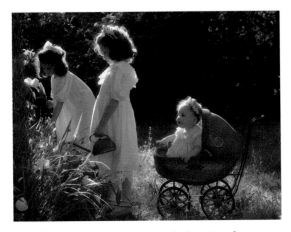

Late afternoon or early morning is the best time for outdoor photography. The angle of the light is low, and it backlights the subjects beautifully.

Beautiful lighting doesn't just illuminate a subject, it can define and describe it, often making it come to life.

This part of our book will help you do two things: learn to find the best lighting available and alter or create it when it is not already present. Everyone needs a firm grasp of lighting technique; these skills are an essential foundation for good photography. But all the technical knowledge in the world won't help you learn to recognize beautiful lighting. For that, you have to study lighting and how it affects the appearance of people and things. Look at different light sources and sunlight at different times of day.

Choosing Exposures

You can set your camera on "automatic" exposure, and under normal conditions you will usually get a properly exposed negative. That means only that you are getting the right amount of light on the negative and that your photofinisher will be able to produce an acceptable print. But that's not enough to make a great print.

Exposure is governed by only four variables: the camera's shutter speed; the aperture of the lens; the intensity of the light; and the speed or sensitivity of the film. Almost all consumer cameras have automatic controls for these, but most advanced cameras will also let you control the settings. If your camera has no manual controls, you can skip the following section and go straight to the one on natural light.

The *shutter speed* is the measure of how long your lens shutter remains open while it lets light pass through to expose your film. Measured in fractions of a second, each setting on your camera is about double or half the time of the adjoining setting. Your *aperture*, measured in *f-stops*, controls the amount of light reaching your film during that exposure time. Though it may seem confusing, the smaller the f-stop, the more light you are letting into your film. In other words, a setting of f 4 allows twice the light to reach the film that a setting of f 5.6 allows. You will learn that shutter speed and aperture are interrelated.

For example, for a sharp-focus shot of a child riding his bike, you would want a faster shutter speed of at least 1/250th of a second. Then, to achieve the right exposure on the film, your aperture might be around f 4, depending on all the other factors. If the child happened to stop riding long enough to let you take a nice portrait of him with beautiful scenery in the background, you could achieve the exact same exposure of light on your film at 1/30th of a second at f 11. The larger the f-stop is, the greater your *depth of field* (depth of field is the amount of the scene, from lens to infinity, that is in apparent focus) will be, which means you can keep both the boy and the scenery in sharp focus. But what if the background is unattractive and distracting? In that case, you can set the aperture at its smallest setting, maybe around f 1.4, while the shutter speed goes to a lightning-

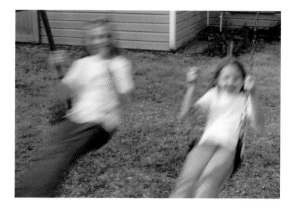 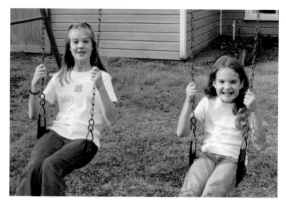

Two identical pictures of children on a swing—the first exposed at 1/15th of a second, the next at 1/250th.

fast 1/2000th of a second. This wide-open aperture will blur out the background while keeping the child sharp.

You will learn in the next few pages that there is a great difference between just obtaining a proper exposure and creating a beautifully illuminated photograph.

Most of today's sophisticated SLR (single lens reflex) cameras offer three automatic modes, known as *aperture-preferred*, *shutter-preferred*, and *programmed* exposure modes. *Aperture-preferred* mode allows you to select the aperture (f-stop) you prefer, leaving the camera to select the shutter speed that will expose your film correctly. This is great for controlling your depth of field—just use a large f-stop to force your entire picture into focus or a small f-stop to retain focus on your subject only. Keep an eye on the shutter speed selected by your camera to make sure you can still hold it steady enough to keep it in focus. Most people can hand hold a camera at 1/60th of a second with no noticeable camera shake, and some very steady-

Guidelines for Selecting Shutter Speed and Aperture

Situation	Solution
Busy or distracting background	Select a large aperture, f 1.4 to f 4, to force the background out of focus
Environmental photograph in which the setting is important	Select a smaller aperture, from f 8 to f 16, for great depth of field
Low light	Use both a slow shutter speed, from 1/30th to 1/8th of a second, and a large aperture, from f 4 to wide open, along with a faster film
A child on the move	Select a shutter speed of 1/125th of a second or faster to freeze the action

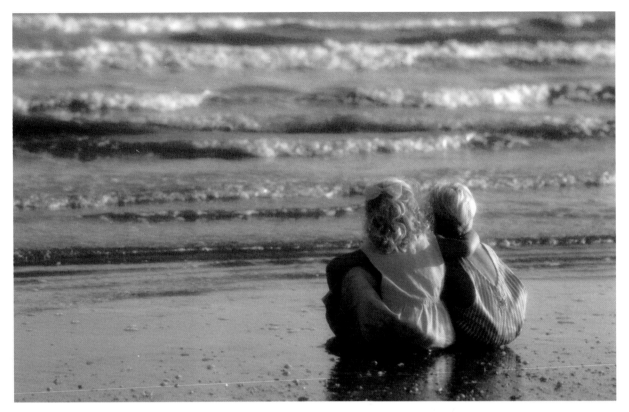

When the light, setting, and pose are just right, you don't even need to show the children's faces.

handed photographers can do so at a speed as low as 1/15th of a second; you'll have to experiment to determine what your own limits are. Camera shake tends to be more of a problem with longer telephoto lenses. *Shutter-preferred* mode is perfect for letting you pick a fast enough shutter speed to keep a moving two-year-old in focus while letting the camera pick the aperture. Of course, in a pinch, you can always select the fully automatic programmed mode and allow the camera to do everything for you, though you give up some creative control to your camera when you do this. Many cameras offer a number of programmed modes, and one of these may be perfect for you.

In general, if we are just walking around with a camera taking pictures in automatic mode, we usually leave it in aperture-preferred mode, and here is why. As long as you select a shutter speed fast enough to keep the child in focus, shutter speed does not in itself affect the outcome of the picture. But changes in aperture always make a difference in the photo: adjusting the aperture changes how much of the photo is in focus (i.e., it determines the depth of field).

When we take photos in aperture-preferred mode, we start by looking at the scene and determining if we would like the foreground and/or background to be in focus or just the child. Then we select the aperture that will give us the focus we want. Most cameras will show you as you look in the viewfinder what corresponding shutter speed was selected. If that shutter speed is fast enough to allow a sharp picture, press the button. If not, just compromise a little on your aperture until you arrive at a workable shutter speed.

We use the shutter-preferred mode in low-light situations to ensure a good focus, particularly if the depth of field is unimportant. We might also use it to photograph a child in motion, such as on a bike or playing a sport.

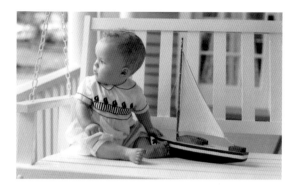

Soft light flowing onto a porch creates a beautiful atmosphere for a portrait . . . and using natural light is easy!

Natural Light

We will start with a light source that everyone can learn to use beautifully, without spending a penny on flash equipment—natural light from the sun. Later on in the book, you will learn how to take advantage of the world's greatest light source, indoors and out. It was good enough for Rembrandt, and you can learn to make it work beautifully for you too. But it can also destroy a potentially great picture when you don't understand how to use it correctly, so we will teach you how to take control of existing natural light and use it to best effect.

Outdoors, you can use the sun by lighting a child either directly or indirectly (such as in the open shade under a tree). Direct sunlight on a cloudless day tends to be harsh and unforgiving, bringing out every flaw in skin and clothing. Children, in general, tend to have even more difficulty than adults in not squinting on a sunny day, even if the sun is behind them. Cloudy days produce a much softer glow, but you will often notice dark circles under children's eyes when most of the light comes from directly above them on overcast days; they will also appear a little flat and dull. (We're describing only the lighting here, not the kids.) This is because there is no *direction of light* illuminating their little faces. The light seems to come from everywhere, and since there are no clear highlights or shadows, the result will

be sort of mushy-looking photographs. We can fix that.

In the open shade of a tree, or even with a piece of cardboard held over the child's head just out of camera range, suddenly there is a direction of light falling on the child, resulting in a soft, flattering illumination. As long as the child's head turns a little bit toward the light, you can capture beautiful images without adding any artificial light at all. Turn off your flash—it would only ruin the lovely lighting that nature has already created.

Indoors, soft, indirect light from a window illuminating the face of a child can create one of the most beautiful images you will ever photograph. Subdued lighting like this may force you to use a shutter speed of 1/30th of a second or slower, making it difficult to hold the camera steady enough for a sharp picture unless you use a prop—try mounting your camera on a tripod or rest it securely on a chair or pillow. Definitely avoid the flash for this kind of shot and use a higher-speed film—ISO 400 or faster (more about film later).

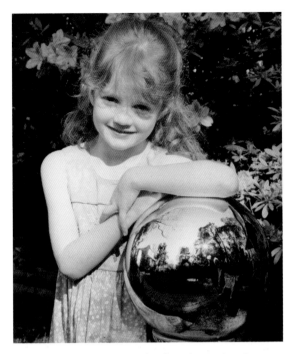

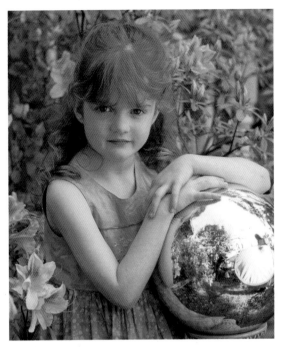

Above : Direct sunlight on a cloudless day tends to be unforgiving, bringing out every flaw in skin and clothing. You can soften and direct the natural light by using a white or silver reflector. (You can see our reflector mirrored in the ball at right.) An inexpensive alternative to a store-bought photographic reflector is one of those long dashboard reflectors sold at variety stores and warehouse clubs.

Below: When there's enough natural light available, be sure to turn off your flash (right); don't spoil the softness of window light with harsh artificial illumination (left). When photographing a child with window light, look for nice lighting in the eyes—there should be a small white "catch light" sparkling in both eyes.

Artificial Lighting

By artificial lighting we mean man-made sources such as lamps and electronic flash. Most flashes are built into your camera, but you can also use separate flash units mounted on the side or top of your camera or a remote unit mounted on a stand. We will talk about the advantages and disadvantages of all these options, but we'll concentrate on explaining the best ways to use the flash that's built into your camera.

Flash is indispensable in a dark room, at night, on a very cloudy day, or when you are trying to freeze the motion of, say, children playing sports. Before you get too much further into this book, dig out your camera's manual and see if it specifies how far your flash is useful with a particular film speed. Most built-in flash units in today's consumer cameras are just about worthless over ten to fifteen feet away. If you are shooting your child's school play from the back of the auditorium, turn the flash off—otherwise, all you will be lighting up are the heads of the increasingly aggravated parents seated in front of you. Taking pictures with the camera's built-in flash in a situation like this is a sure sign of inexperience.

Another major problem with the built-in flash in your camera is the way it produces the *red-eye* effect in your subjects. Even though some children may act like the devil at times, you probably don't want them to look that way in a photograph (unless, of course, it's Halloween). The problem is

A built-in flash often causes "red eye." Sometimes this can be eliminated by using the automatic "red-eye" reduction feature on newer cameras. If that doesn't work, you can touch up the print by using a special "red-eye reduction" felt-tip pen or, if your image is digital, by using the sponge tool in Photoshop to desaturate the red.

that the blood vessels in the eye's cornea act as a mirror to the flash. Since a built-in flash is so close to the camera lens, it reflects the cornea's red blood vessels directly back into the lens and onto the film.

Many newer cameras have a built-in feature called *red-eye reduction*. What this does is to send an annoying series of light pulses to your subject a second or so before taking the picture. The theory is that the person's pupils will contract, covering up most of the area from which the redness originates. The reality is that the light pulses generally make people squint without really doing a whole lot to counteract the red-eye problem; they can also make you miss the crucial second of an action shot while your camera is firing out those little light pulses.

The only sure way of eliminating red eyes in flash photography is to mount a separate flash unit on your camera's hot shoe receptacle or, if your camera will allow it, connect them together with a cord. This increases the distance between the lens and the flash, which does a good job of avoiding the red-eye effect. These flashes are more powerful than those built into a camera and allow flash photography from a greater distance. However, they do add some bulk to your camera as well as cost money for the extra flash unit; also, some cameras simply don't have the proper connections to add a separate flash unit. Check your manual.

Lighting for Mood

Lighting is a great tool to convey a child's mood and personality. As a rule, bright, even lighting with little or no shadow is best suited to a picture of a happy, carefree child at play in the park. Using more directional light sources to create some shadow on the face is a great way to portray a more contemplative child or to capture a serious,

The built-in flash units on today's consumer cameras are just about worthless if you're more than ten or fifteen feet away from your subject, as was the case here.

Most cameras that have interchangeable lenses and a built-in flash have a strong enough flash to light up the stage, if you use a film with an ISO of 800 or higher. But the flash will also light up the heads of the people sitting in front of you—an annoying distraction.

If you need to photograph an event using only available light, try using a film with an ISO of 800 or higher. If possible, mount your camera on a tripod so there's less risk of blurring the shot.

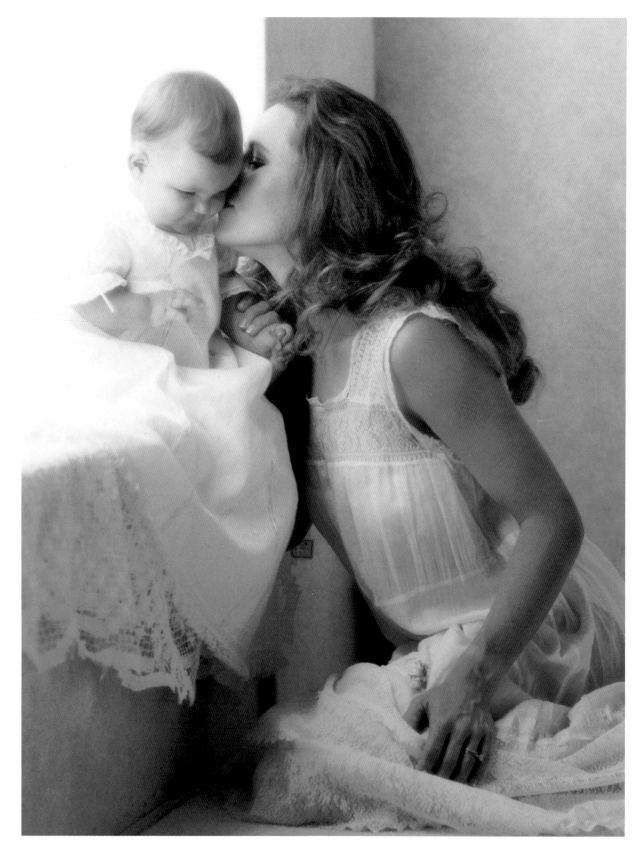

The combination of strong highlights and deep shadows
reinforces the loving intimacy of this image.

thoughtful mood. This is ideal for a child reading a book, smelling a flower, playing an instrument, or gazing out a window at the rain. Lighting from more of an angle also brings out more of the texture in clothing and other props. Look at the examples in this chapter and note how the varying qualities of light help set the mood of the picture.

More about Proper Exposure

Once you find or create the best lighting for the picture you want to make, you still need to get it on film. In a typical situation, most cameras today do a fantastic job of automatically setting the focus and exposure controls. Later in the book, we will show you some more advanced ways of getting the best possible exposure by manually taking over from your camera's automatic features, which will expand your creative boundaries.

How important is proper exposure? Look at the examples on the following pages. Compared to films from just a few years ago, today's films do a great job of making beautiful prints even when the

Making the Right Choices

Some situations call for a certain shutter speed or a certain aperture. Occasionally you will need to make an artistic decision as to which is more important.

This quick-reference table, along with your own experience, will help you make the right decisions.

Situation	Action	Option
Kids at play	Use a faster shutter speed (minimum 1/60th of a second)	Might require a wider aperture than desired and/or a faster film
Large group	Use a smaller aperture (f 8 or more)	Small aperture keeps a larger group in focus but might require a slower shutter speed or faster film in low light
Full sunlight	Use a slower film	Lets you use a slower film, faster shutter speed, and smaller f-stop, but beware of harsh shadows and highlights
Overcast, dim light	Use a faster film (minimum ISO 400)	Allows you to take pictures without a flash but yields photos with more visible grain
Indoors	Use a faster film or flash	If you can make use of nice light from an open door or window, do it. Otherwise, use your flash.

exposure was grossly misjudged. But when you do miscalculate the exposure, an overexposed negative (one that receives too much light and looks very dark when you hold it up to the light) gives you an overly contrasty picture, with more visible film grain than in a properly exposed negative. Underexposure creates a very "thin" negative, with little image information, yielding a flat, muddy picture with no pure blacks. Many underexposed amateur pictures result from shooting in a dimly lit setting with the subject too far away to be illuminated by the camera's built-in flash. In general, overexposure is far preferable to underexposure.

The Final Ingredient

When all is said and done, lighting isn't nearly as important as the expression on a child's face. Twenty years from now a wonderful smile that is badly underexposed will warm your heart and touch your emotions much more deeply than a perfectly lit picture of a child who looks bored or stiff. In children's photography, expression is just about everything. Give children something fun or creative to do, let them loosen up and be themselves, and get the result on film as best you can. You really can't take a bad picture of a great expression. And remember that, in the long run, film is cheap. It is always better to try a few different lighting ideas than to take just one shot and hope for the best.

Opposite: Sometimes the best way to capture a child's essence is just to let him be himself. A lot of times that appealing naturalness is lost when a child is cleaned up, dressed up, and perfectly posed.

Lisa Jane has taken many award-winning photos of her son over the years, but this candid shot is one of her favorites because it catches him doing what he loves best—catching polliwogs in their pond. Her first impulse was to wash his face and change his shirt, but that would have made her lose the moment. She used a high camera angle because it seemed so natural to be looking down on him as he proudly showed off his great catch.

The underexposure is flat overall, with weak shadows.

This overexposure is contrasty and grainy with an overall harshness.

An accurate exposure gives excellent detail throughout, with nice, natural skin tone.

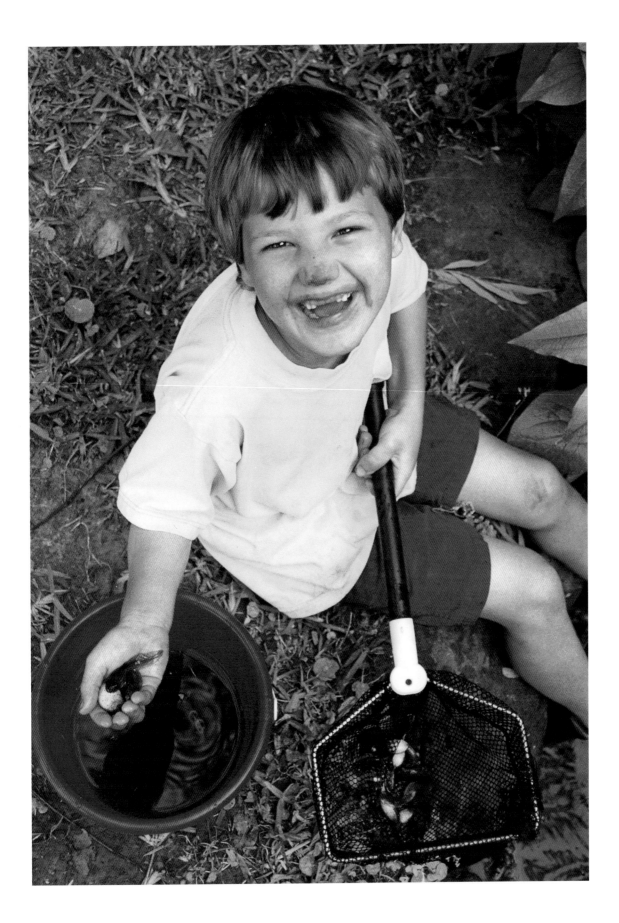

3. The Tools You Need (and Don't Need) to Do the Job

Chances are you probably already own some sort of camera. If so, you may want to skip this chapter or come back to it later just to see what else is available. In addition to cluing you in on the possibilities and limitations of certain cameras, we will also cover some of the more popular and useful accessories. We hope you will find that the camera you already own is just perfect for your present needs, but you can't know that for sure unless you find out what else is out there. And if you just have to own the latest in state-of-the-art toys, you will certainly find a good excuse or two in this chapter to go out and buy something cool.

Consider starting out with a small investment

in equipment and then upgrading it as your skills and creativity warrant, just as you would with any other hobby. How many friends have you seen catch the fever for scuba diving or skiing or some other activity, go out and buy the best of everything, use it once or twice, and then later practically give away all their expensive gear in a garage sale? This chapter will help you navigate the sea of equipment choices so that you can make an educated decision on how to invest your hard-earned money wisely.

The great thing about photography is that whatever equipment you buy, you can use it for years to come, if you opt for high quality in the first place. If you just won the lottery, buying expensive new camera equipment is a fast way to splurge, but you can also find great values in quality used equipment in any big city or from one of the many reputable mail-order houses or Internet sites. In our daily studio work we both routinely employ cameras that are over twenty years old. You really don't need to spend a small fortune on equipment to create good photographs. No matter how sophisticated or simple the gear, the most important factor is the person behind the camera.

This chapter will describe what types of cameras are available today and provide basic information about how they function, but due to the variety of features available on the many different cameras, we strongly recommend studying your own camera's manual for specifics on film loading, focusing, and so on. We will also concentrate solely on cameras that use 35 mm or APS films. You can still find cartridge-loading cameras on the market that accept 110 film cartridges, but the leap in quality from 110 to 35 mm formats is so impressive that we will basically ignore the former.

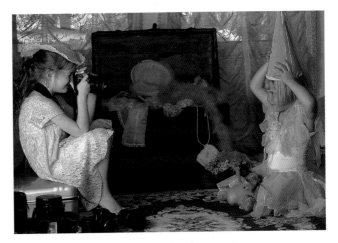

Choose a camera with both manual and automatic options. Automatic settings are the easiest to use, but manual settings allow you more creativity.

Disposables

So, where do you start? If you don't already own some kind of camera, you can run down to the drugstore and buy a simple disposable (one-time use) camera. Think you can't create a great picture of the kids with a disposable? Think again!

Let's look at disposable cameras and talk about what you can and cannot accomplish with them. For starters, they are dirt cheap and can be bought almost anywhere. Ever go to the beach and then discover that you left your camera at home? Just run into the local convenience store and pick up a disposable. It's good to know you can drop your disposable in the sand without harming it, whereas dropping your state-of-the-art SLR camera in the sand could cause serious heartbreak.

Disposables are probably the simplest cameras to operate ever conceived. They come loaded with film and ask you only to wind, point, and shoot. They generally are factory loaded with high-speed film, so that you can take pictures almost anywhere and get acceptable focus and exposure, although you will notice a little more film grain if you try to enlarge your shots. These cameras are lightweight and portable, fitting right into your shirt pocket. They are maintenance free and so mechanically simple that malfunctions are almost

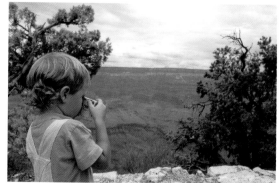

When Lisa Jane went to the Grand Canyon for a family vacation, she gave her boys a mini photography lesson and then gave them each a disposable camera with his name on it. They came up with some creative camera angles and some wonderfully spontaneous ways of photographing each other.

unheard of. Many even come equipped with a little flash unit built right into them, batteries included! Some are designed to use underwater, making them the most affordable way to take pictures of kids while you are all in the pool or snorkeling by the beach. Another option is the "panoramic" disposable, which lets you take wide, 4 x 10 in. slimline photographs—ideally suited to nature scenes. When you finish the roll, just drop off the entire camera at the photo lab and, voilà, you'll have pictures. (Most of these cameras are then recycled to help save our planet.)

Even if it runs contrary to everything you hold sacred, quickly read the brief instructions printed right on the disposable. They will tell you that the little flashes are worthless more than eight to ten feet away from your subject, so in dim lighting make sure to move in close enough for the flash to have an effect. However, also read to find out what the *minimum* distance is for the flash and focus. If not, you might move in for a tight close-up and then be disappointed later with a completely overexposed, out-of-focus picture. We recommend always buying the model with a built-in flash. These little cameras have no idea if the scene needs a flash or not, but even on a sunny day, that little burst of light can soften harsh shadows on a child's face.

The lens on a disposable camera is definitely not going to produce a picture as sharp and crisp

as one taken by a more elaborate camera, and you have absolutely no control over creative camera settings such as shutter speed and aperture. However, once you have read our book and learned how to make the best of natural light, how to select a suitable background, and how to compose your picture effectively, you'll be able to create great memories with even the simplest disposable. The joy of using these ingenious little cameras is in their complete simplicity—this is a camera that Henry David Thoreau could have taken to Walden Pond!

Point-and-Shoot Models

Modern 35 mm cameras are available from the simplest "point-and-shoot" compact cameras to very versatile and advanced programmable SLRs (single lens reflex cameras). Start with a quality compact 35 mm point-and-shoot camera with built-in auto-focus. Cheaper models might offer only fixed focus, which may or may not produce a sharp focus but will certainly limit your creative options. Remember that in auto-focus mode, your camera will focus on whatever it sees in the center of the frame, which means that if a child is positioned off center, he'll be out of focus but the trees centered in the background will be nice and sharp.

Consult your manual to learn how to override this feature. In most models, you do this by placing the center of attention (i.e., the child) at the center spot in your viewfinder. Push the shutter-release button down just far enough so you can see (and usually hear) the lens adjust the child into sharp focus. Continue holding the button down while moving your camera to frame your final composition before pushing the button the rest of the way down to take your picture. Believe us, this is easier than it sounds.

Find a camera with a zoom lens that has a focal length ranging from around 35 mm to 85 mm. A broader range of zoom length is fine but not necessary if it doesn't fit into your budget. (We will talk more later about using your zoom lens.) Try to find a camera that has a receptacle on the bottom that will allow you to mount it on a tripod. A sturdy tripod is indispensable when you are taking pictures by window light and in other low-light situations. If you can, select an automatic camera within your budget that also allows you to manually adjust the shutter speed, aperture, and focus. Though you may not understand their functions and usefulness yet, they will definitely prove useful as you develop your skills. These features are not essential to making great pictures, but learning to use them opens the door to more creative pictures.

APS Cameras

What about APS, the Advanced Photo System cameras? These cameras feature a unique technology, developed together by several leading camera manufacturers, that makes point-and-shoot cameras even easier to use. Loading and unloading the camera is effortless, and when your pictures come back, you also receive a helpful little "index print" with all of your pictures on a single page, to help you catalog your negatives and reorder later. The downside is that APS cameras use a smaller negative than traditional 35 mm, so you will notice more grain when enlarging your images; also, APS film is currently available in fewer types and varieties than 35 mm.

Advanced Photo System cameras allow you to create pictures in any of three different formats: C, H, and P. C is the common format you would ex-

This scene was shot using the P (for panorama) format of an Advanced Photo System camera.

pect to get from a traditional 35 mm camera yielding a 3 1/2 x 5 in. or 4 x 6 in. print. H is the format corresponding to the new high-definition television (HDTV), producing a 4 x 7 in. print. Finally, P yields a panoramic print measuring 3 1/2 x 11 in. or 4 x 12 in. print. Whatever the ultimate format, the image is actually recorded the same way on the film, but the code embedded on the film as it is shot instructs your photofinisher which format to use in printing it. This feature allows you to change your mind about the format at a later time.

Another useful feature found in some of the better APS cameras is mid-roll change (MRC) capability. Say you were photographing in black and white and along comes a beautiful sunset. This function allows you to take out your black-and-white film, load and shoot some color, and then reload your roll of black and white. The camera then rolls your film right back to the previous position. This eliminates film waste and is cheaper and more convenient than toting around two cameras.

When you pick up your film from the lab, you won't get the usual envelope full of orange negatives. Instead, your processed film will be stored conveniently in its original cartridge, along with your index print. Each APS print is encoded on the back with date, roll number (matching the code number on the film cartridge), frame number, and time. Better APS cameras will allow you to record whatever additional personal or technical information you want on the back of each print, in any of several languages.

APS is a fully viable alternative that is here to stay, but we still recommend the traditional 35 mm format. The choice, though, is ultimately yours: APS convenience vs. 35 mm quality. Start by doing some reading, and then have your photo retailer show you the difference in quality between a normal 35 mm enlargement and an APS image in the

same size. Magazines such as *Popular Photography* and *Modern Photography* as well as *Consumer Reports* offer volumes of information about both 35 mm and APS—keep browsing until you find the magazine that tells you what you want to know.

Accessories

We also suggest the following simple accessories, any of which can be used with any camera. First, make a simple reflector. This can be used for reflecting light into your subject's face and eyes in different situations or for blocking harsh direct sunlight from the face. Just find a piece of cardboard or some other flat, lightweight material. Cover one side with aluminum foil and spray paint the other side bright white. If you are not the do-it-yourself type, you can go to any good camera specialty store and buy professional-quality reflector panels that are very flexible, practical, and durable, and fold away into a very small package.

A good tripod is always a great investment for any camera with a tripod mount built into the bottom. You could always just try to find a flat surface on which to steady your camera, but what if the need arises and there is no stable surface avail-

Below left: A sturdy tripod with a quick-release mount can be used with nearly any good camera. It is a worthwhile investment that will improve your photographs.

Below right: Adapters and filters can greatly enhance the look of your photographs. You can make the filters yourself, or purchase them from your local camera store.

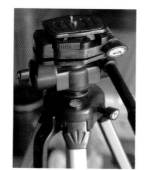

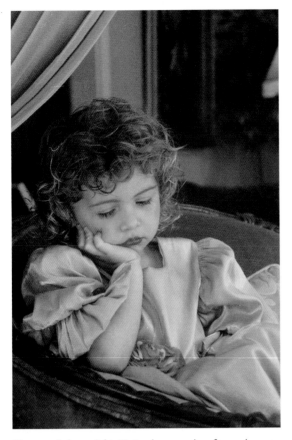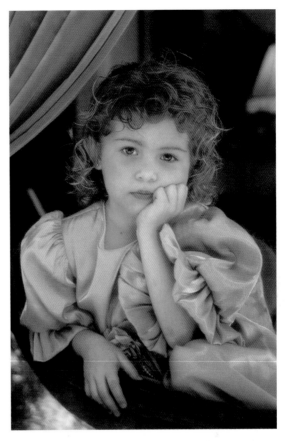

Above and above right: Notice how much softer and more appealing the image is when a filter is used, as in the photo on the right.

able? Buy a nice, lightweight tripod sturdy enough to hold your camera still but light and convenient enough so that you won't be tempted to leave it behind when you go out to shoot.

Soft, beautiful effects can be created with homemade soft-focus filters. A terrific filter can be made by stretching gauze or netting over a frame constructed of some simple, stiff material. Panty hose material, for example, works well, but experiment with different fabrics to see which work best in different situations. You could spend hundreds of dollars on photographic filters, but it is hard to beat the natural softness created by holding one of these simple homemade filters in front of your lens.

Tiffen, a well-known filter manufacturer, offers an adapter designed to hold their filters, which fits right on the front of many lenses. You will probably want to own a few store-bought filters at some point, but you can also design your own to fit into the same adapter, rather than just holding them over your lens. It's handy to stock a variety of homemade or commercial filters made with one, two, or three layers of diffusion materials. You can poke a hole or a pattern of holes in one or two of the layers to let the center of your pictures stay sharp while the edges gently go a little softer; this directs more attention to the child than to the background. You can use a neutral-color material or even try making some filters with brown or maybe blue materials to cast a creative hue on your pictures. This is where your imagination can really start to play.

When choosing a camera system, it is important to find one that suits your needs and fits your budget.

I'm Serious . . . I Want to Spend a Little Money

If you plan on becoming more serious about taking creative control, you may eventually want to own a high-quality 35 mm SLR camera, with probably two or three interchangeable lenses. There is another type of camera commonly called a *bridge camera*, which has the versatility of an SLR combined with the portability and ease of use of a compact point-and-shoot. We're skipping over that option because if you are really interested in making great pictures, we think you should bypass the bridge cameras and jump right into the SLR market. You can easily find high-quality used camera bodies with fully manual controls, but in the long run you will probably be happier with one of the newer bodies on the market, with their myriad exposure modes, lightning-fast focusing controls, and other helpful features.

The list of features available on today's cameras is mind-boggling, and the technology is evolving so quickly that anything we say here will soon be obsolete. We will give you some good pointers, though, as to what features you really have to have. We have both used Canon cameras since high school, but there are at least five or six other manufacturers with excellent reputations and good service track records. Find a camera that has all the features you need, is priced right, and feels comfortable in your hands. To avoid initial frustration, ask the salesman to show you how to load the film correctly and how the primary features function.

Your camera should have all of the following:
+ Both fully automatic exposure and auto-focus modes, along with complete manual overrides.
+ A built-in flash is very handy, but find a camera body with a hot shoe, a receptacle that will allow you to add a separate flash if you want one later on.
+ A lens or a combination of lenses that offers you focal lengths ranging from about 28 mm up to 135 mm—even longer is good, if you can afford it, but this recommended range is plenty for the vast majority of children's photos. A "fast" lens with a smaller f-number will allow faster shutter speeds in low-light situations and can be a great help when you're trying to keep active children in focus. The faster the lens, the more expensive it is.
+ These essential features are pretty much universally available on today's SLRs, but check to make sure that yours has them: a self-timer, a built-in motor drive to advance your film quickly and accurately, a tripod adapter socket, aperture- and shutter-preferred auto-exposure modes, and user-friendly controls.
+ Believe the salesman when he recommends that you buy a skylight filter to protect your valuable new lenses from the elements. They are much cheaper to replace than a lens. We actually prefer a UV/haze filter to a skylight filter, as it can help warm up the bluish cast often found in shadows outside.

Important

Always keep an extra camera battery or two in your bag. Batteries inevitably die at the worst possible moment.

That's it. A camera with these features plus a new roll of film and a backup battery are really all you need. Everything else is either fluff or better suited to photographing something other than children. Today's cameras often have so many options on them that they can sometimes make picture taking harder than it would be if the camera had fewer unnecessary features. Make sure to buy a camera that doesn't overwhelm or intimidate you. Don't forget rule number one: this is supposed to be fun!

I'm Serious, I Have Plenty of Money, and I Want to Spend It Now

So you really want to take the plunge into this wonderful hobby. Great! In addition to what you may already own, you could make an offer for our own "pre-owned" professional equipment and let us buy some fancy new stuff, or you could consider the following.

Acquiring another lens is always fun and expensive. Go for one that will take you out to the 200 mm midrange telephoto arena. Not only can you create some really interesting portraits with this lens but you will also be able to use it for sporting events, nature photography, concerts, and any situation where you can't get close enough physically. Lengths longer than 200 mm are normally not needed for photographing children, even from a distance, but they look really cool on your camera and give other photographers a condition known as "lens envy."

Faster lenses are better still, but a really fast midrange telephoto from a top camera company can get really expensive really quick. (But you don't care anymore, do you?) Because they are more susceptible to camera shake problems, longer lenses also make the convenience of a rock-solid tripod even more important.

Probably more useful than a big lens is a sep-

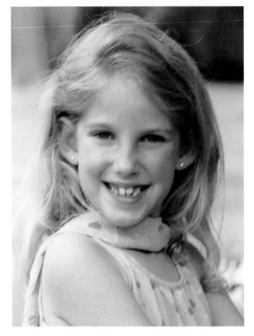

Lens Selection
Does the lens focal length make a difference? Take a look at these two portraits. Notice how moving in close with a 28 mm wide-angle lens (top) distorts her facial features. Additionally, a wide-angle lens has a deep depth of field. In this case, it brings all the background distractions into sharp focus.

Backing up several steps and using a telephoto (bottom) produces a much more natural result. In addition, it throws the background out of focus to help hold our attention on her expression.

A built-in flash (shown open and closed above) may be more convenient, but because it is so close to the lens of the camera, it often causes "red eye." A larger flash (right), mounted on the hot shoe of the camera, usually eliminates that problem. It also gives you control over the amount and direction of the flash's illumination.

arate flash unit that attaches to your camera body's hot shoe, either directly or with a cord or radio-controlled device. Later in this book you will discover the wealth of effects you can create with a flash unit not built directly into your camera. But more immediately, a separate flash eliminates most of the red-eye effect commonly created by built-in units.

Portable electronic flash units can be attached to a camera in three different ways. They can be attached most easily by insertion into the hot shoe located on top of a camera body. This is certainly the quick and easy route, requiring no cables of any sort. If you want to be able to hand hold your flash in different positions while making pictures, you may want to buy a pc cord, which links the camera and flash together. A third and more expensive option is to trigger your flash unit with a radio remote-control unit, which is produced by Quantum Instruments and others. This allows cord-free operation of your flash unit at great distances; again, we will explore all three options in great detail later on (see pages 68–71).

There are several companies—including Vivitar, Quantum, and Sunpak—that specialize in building high-quality flash units for your camera.

Your own camera manufacturer also offers a selection of flash units for your system, with a range of features and flash power. Regardless of your choice, you will probably want a flash unit with the convenience of TTL ("through the lens") operation. This innovative technology reads the amount of light as it is bouncing off your film and then controls the intensity of the flash needed. TTL is a great way to obtain a precise exposure, but you should also select a flash with full manual operation so that when you want it, you can have full control over your image making.

The Future Is Digital

Even though the vast majority of photographs are still being made using traditional silver-based film, digital imaging has become a fact of life in photography today. Digital imaging is nothing less than astounding, both technologically and artistically, and you need to be aware of its potential. Nonetheless, beautiful children's photography can be created with any type of camera in any kind of format, whether analog or digital.

It is difficult to write definitively about digital cameras and the technology behind them because that technology is reinventing itself at such a light-

This was taken with a Kodak 260 digital camera, with a file size of 4.5 MB.

ning pace. We are going to share with you some of the basic information about digital photography today, but we recommend that you do some research in the popular camera magazines and on the Internet before plunking down your hard-earned cash for one of these exciting and expensive new toys. They are very useful in many situations and lots of fun to play with, but just as with buying a new computer, be prepared for your investment to be outmoded in a couple of years or so. It will remain a useful tool, but you're likely to start feeling that you just have to go out and buy the latest, fastest, sleekest new model. It is also fair warning to say that digital cameras today are probably best suited for photographers who are quite at home in front of a computer monitor.

The basics . . . With a traditional 35 mm cam-era, we look at the quality of the lens, the speed of the film, and the accuracy of the focusing system to measure the sharpness of our pictures and the degree to which we can enlarge them. In the digital world, there are different parameters to consider.

The most important factor to consider is the camera's resolution, stated in megapixels, which is a measure of how much digital data is recorded when you take a photograph. It correlates most closely to film speed in the 35 mm world. Higher film speeds produce more grain in your photos, limiting how large you may want to print them. In digital photography, the more megapixels of information recorded, the larger and sharper your image can be once it's output to a digital printer.

At this writing, the standard for most consumer cameras is in the range of two megapixels. That is about double what one could purchase just last year. Pro models costing several thousand dollars will record upward of six to eight megapixels. The consumer models now available will produce excellent 5 x 7 in. prints and quite acceptable 8 x 10s printed right off your computer's inkjet printer.

Digital cameras make your choices a bit more complicated by offering a range of resolution settings from which to choose when taking your photos. You can set it at the maximum resolution of around two megapixels to achieve a good 8 x 10, one megapixel to achieve a good 5 x 7, or lower resolutions that are basically just sufficient to create images for Internet usage. These levels are often given names such as "good, better, best" on your camera. Larger files also take longer to read into your camera and occupy more space on your memory card, which is our next topic.

Where's the film? Well, there isn't any. When your digital camera takes a picture, it stores the image onto a memory card. (This is similar to what

your desktop scanner does when copying a photo to your computer's hard drive.) Your memory card, which is removable and reusable, may contain anywhere from 4 MB (megabytes) of storage to 80 MB. As you might expect, the bigger the storage capacity, the more expensive the camera. When you're packing your camera to take on vacation, you will also want to take several of these cards to record the whole trip. One fabulous feature in digital is that right after you take your image you get to see it on the LCD screen on the back of your camera. If you don't like what you see, just hit a button and erase it from your memory card. Then either retake it or move on to the next shot. You can fit about twelve high-resolution images in low-compression JPEG format on an 8 MB card, and about double that number of one-megapixel images.

When shopping for a digital camera (which will be at least double the price of a comparable 35 mm), do your homework, just as you would before buying a traditional camera. Look for a camera with both a traditional viewfinder and an LCD viewing screen on the back. Using only the LCD screen burns up batteries in a hurry, so use the traditional "look through" viewfinder when possible.

The three images shown here were all taken with digital rather than traditional film cameras. The quality of the resulting images is directly related to the quality of the image as it is captured on the disk. The file size, measured in megabytes (MB), and the quality of the optics are very important in determining the image quality.

Opposite: This was taken with a Phase One digital magazine mounted on a Hasselblad professional camera. The 17.5 MB file size and superb optics yield a beautiful image that could be enlarged to wall size without losing sharpness.

Above left: Taken with a Canon S-10 digital camera, this image is printed from a 2 MB file. It will make a nice 5 x 7 in. print and a reasonable 8 x 10, but that is about as large as it can go. However, it is a great format for images that you want to put on the Internet.

Above right: This image, taken with a Canon 520 digital camera, was captured as a 5.7 MB file—perfect for creating images that rival film in quality, up to 16 x 20 in. enlargements.

Pick a camera with a 3:1 zoom lens or better. Some cameras will capture and record the image faster than others, so you will also want to compare transfer rates. If you are photographing an active baby doing something cute, you may not want to wait eight seconds between shots for the camera to recycle.

Like traditional cameras, digital models offer a range of features and controls. Some are going to be very tempting to you, so decide what you think you will really need before making your purchase. If you are buying the camera at a traditional retail outlet, ask the salesman to let you play with it enough so that you get a feel for the operation of the model you are considering. Sometimes you'll find that a particular camera will just feel right in your hands, and if it has the features you want, that's likely to be the one you should buy.

4. Choosing a Film

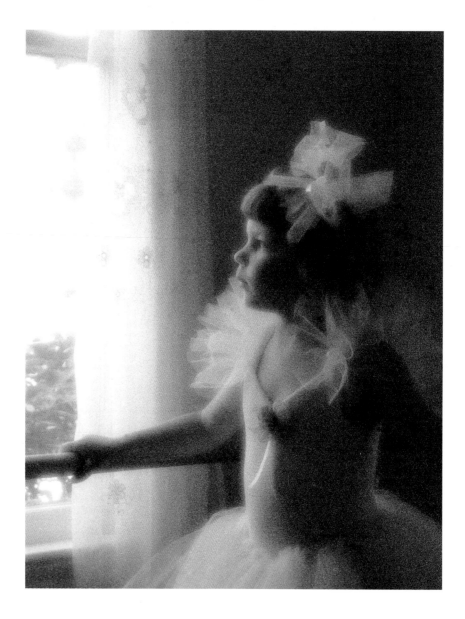

Have you been to a camera store lately and looked over the bewildering array of films now available? If you walk in off the street without at least a basic understanding of how these films work, you will be forced to rely on the vast knowledge of the part-time sales clerk who started just last week. We receive more questions about which film to choose than just about any other topic, so we'd like to offer the following advice.

Film is available in a variety of sizes, from the small 110 cartridges up to sheets of film measuring 20 x 24 inches. We will concentrate on 35 mm

film here. (If you have opted for a digital camera, you may not feel the need to read this chapter. Just remember what we said about traditional film cameras being capable of outperforming digital cameras that cost several times more.) Some less expensive cameras will function properly only within a certain range of film speeds; check your manual to make sure. Films come with a "develop before" date printed on the carton. You can usually go a little beyond that date in a pinch, but try to use the freshest film possible. Old film—as well as film that has been exposed to heat, direct sunlight, or high humidity—can result in pictures flawed by abnormal color or worse, so store your film in a cool, dark place. A refrigerator drawer works well. A car dashboard does not.

Let's take a stroll to the film counter to see what's available and figure out which ones we might want to use. You may notice lots of unfamiliar words as we discuss these films; just take your time and read over the text a few times until you have a comfortable understanding of the basics. After absorbing this information, you will know exactly what type, speed, and brand name to choose before you even arrive at the store.

Color Print Films

These are the films that most of us are accustomed to using. When properly exposed and processed, they yield a color negative from which the lab can create a color print. This is the easiest film with which to take a pretty picture, and it's more forgiving than slide or black-and-white film; even if you miss the proper exposure by a considerable margin, your photofinisher can still produce a reasonable print. So, what is the difference between all of those color-print films behind the counter?

First of all, there is the film's speed, or ISO rating (ISO stands for the International Organization

for Standardization), to consider. All you need to know is that the higher the film's ISO number, the more sensitive it is to light. A film with an ISO rating of 200 is twice as sensitive to light as one of ISO 100. Higher ISO films (some go as high as ISO 3200) allow you to shoot in very dim light without resorting to flash.

If you'll be in a low-light situation where you either cannot use your flash or choose not to, opt

By choosing a film with an ISO of 800 or higher, you'll be able to shoot indoors using available light (top). The result is warmer and more rounded than the cold, high-contrast effect obtaining by using a direct flash (bottom).

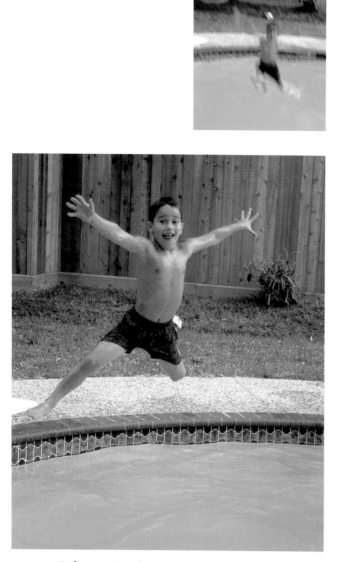

To freeze action, choose a high ISO film (400 or 800) so that you can use a faster shutter speed. These photographs illustrate the difference between a shutter speed of 1/15 (top) and 1/500 (bottom).

for a high-speed film of ISO 400 or higher. This should also be the choice if you are photographing your child's swim meet and want to freeze the action with a high shutter speed (more on shutter speeds later). Just be forewarned that a higher film speed has the drawback of producing more noticeable film grain in your enlargements and usually a slight loss of color saturation and contrast. But these problems are much less serious than using a

lower-speed film that produces nothing but a bunch of dark or blurry pictures.

If you are taking pictures at an outdoor picnic or the beach, a lower film speed, such as ISO 100 to 200, will perform well, yielding richly saturated colors and enlargements with little graininess. Just have a flash on hand in case you wind up going inside when the rain comes along or if you want to keep photographing toward sunset, when less natural light is available. These lower-speed films are much better suited to photographers working with more sophisticated cameras that have faster lenses. Photographers taking pictures of fast-moving kids, inside or out, should probably stick to higher-speed films to ensure a good photo almost every time.

On the other hand, if you are photographing a grand scenic vista with a child very small in the frame, and if you plan to make a very large wall print from it, you can use a color-print film that is

Film Freshness

All films have an expiration date printed on the package. As film gets older, it deteriorates in both color and overall quality. This does not mean that you should throw out your film if it falls a month or two out of date. But we advise against buying "bargain" out-of-date film just to save a dollar or two.

Equally important is storing your film in a way that keeps it fresh. Stash your film in a resealable bag in the fridge; do not just toss it into your car's glove compartment. Heat and humidity are the great enemies of film (and of photographs too, for that matter). Exposed film can also deteriorate in quality after sitting around for a couple of months, so after you have finished a roll, make it a practice to process your film as soon as practical.

even slower and less grainy than the ISO 100 films, notably Agfapan 25. You will very likely require a tripod to steady the camera for the longer shutter speeds usually required, but you will be amazed at the quality of the resulting large print.

The best all-around film to use with a good point-and-shoot camera or an SLR is one with the compromise speed of ISO 200. It is fast enough to use in almost any situation and, when properly exposed, low enough in visible grain to enlarge to 11 x 14 in. or so.

In an average to less-expensive point-and-shoot, make your standard film an ISO 400. In a snapshot-size photo, the difference between the latest ISO 100 and 400 films is negligible; only in enlargements will you see a substantial difference. It's smart to keep a roll each of ISO 100, 200, and 400 in your gadget bag, just in case. It is also nice to have a roll of ISO 1000–1600 film stored there in case you have an unexpected opportunity to take a great photo just after sunset, when a slower film just will not do. The 1000 and faster films have a very pronounced grain structure, but this graininess can often be used to artistic advantage.

By choosing high-grain film, with a ISO of 1000 or more, and by adding a soft-focus filter, you can create a beautiful effect—more like a pastel drawing than a photograph.

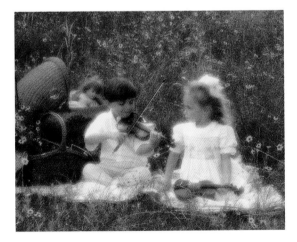

The old-fashioned slide show is a time-honored way of showing off a child's special moments.

Color Slide Films

Slide films such as the Ektachromes and Kodachromes we all grew up with make slides (also referred to as transparencies). If you are going to create a slide show about your children, this is what you want to buy. Slides offer a color quality, sharpness, and realism simply impossible to capture in a print made with color print film; they can look almost three-dimensional. It's fun to give slide shows at a party, but keep in mind that not everyone will be as excited as you are about sitting through a narrated presentation of your 250 favorite slides of little Billy on the latest family vacation.

If you buy a film with the word *chrome* in any part of its name, you will receive slides, not prints, from your photofinisher. But be aware that there are some slide films out there without *chrome* in their name, so make sure you know what you are buying before you take it out of the store. (You can find much more information about individual slide films than we have space to offer here from Eastman Kodak and other major film suppliers.)

Slide films come in an even wider variety of speeds than print films. Some are for daylight use and some for tungsten (incandescent) lighting, so read the label carefully. (Your camera's flash is compatible with those intended for daylight use.) These films are finicky: you can't stray too far from

the proper exposure and expect to get a great slide. Just in case, we recommend that you bracket around what you think is the right exposure—i.e., intentionally over- and underexpose the film one f-stop each way—if your camera allows you to do so. We also recommend that before trying out slide film you carefully study our section on getting the correct exposure on your film (see chapter 2). Though pretty much any camera bought for more than $150 should be able to take pretty good slides in most conditions, there are several special lighting situations that could fool both you and your camera. And, unfortunately, even though you can save an improperly exposed color print negative in the printing stage, with slide film what you exposed is pretty much what you are going to get.

Paper photographs can be printed from your slides, but expect them to be more contrasty and color saturated. They tend to be great for nature shots and other images in which high contrast and strong color are often desirable but not quite as well suited to making portraits with soft, natural skin tones. Slides can also be used to create larger paper prints with less grain than those made from color print film with the same ISO. Again, the print quality will depend very much on your making a near-perfect exposure when you take the original picture. If you need only an occasional slide, just find a processing lab that will make a color slide from your color print negative. Then you can have both prints and slides from the same original negative.

Black-and-White Films

We love black-and-white (also called monochrome) images. They are far more archival than color images (i.e., less susceptible to fading), and they can make a beautiful, timeless artistic statement. The black-and-white photo has been in exis-

tence much longer than color photography, and many photographers specialize in nothing but black and white. Most people find black-and-white photography far more challenging than color, probably because it is an entirely different way of seeing things. To make your black and whites visually effective, you must learn to use the elements of form, texture, and contrast.

You will find a variety of film speeds and manufacturers from which to choose. Like color print film, black-and-white film yields a negative that the photofinisher then prints to paper. Black and white is more expensive—and slower—to process and print, for it normally must be done by hand rather than fed through an automated film processor. However, black and white is much easier to process in a home darkroom, if you ever consider venturing into that realm of creativity. Countless factors affecting the final outcome of your image—from developing-solution times and temperatures, variable-contrast grades of papers, and the myriad methods used in printing on those various papers—all make black-and-white photography an art form unto itself.

Since most readers of this book are going to make the overwhelming number of their pictures in color, we will leave a full exploration of black and white to other books dedicated specifically to it. However, we do urge you to see how much fun you can have with it. Use both color and black and white to take some identical compositions in a variety of situations and then compare the results. Not only will you begin to determine your own preferences but you will also learn a lot in the process. (In a later chapter we will show you some creative ideas for hand tinting your black-and-white images.)

Attractive alternatives to black-and-white film are the new chromogenic films, which yield black-

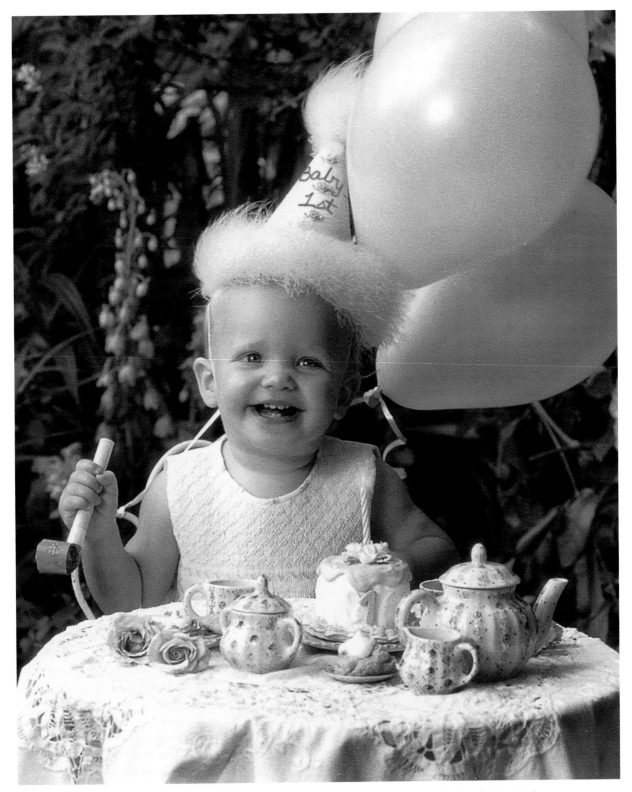

Because first birthdays are so special, you may want to go to some extra trouble to create a birthday party set-up. Since black-and-white photographs last longer than color prints, it makes sense to use black-and-white film for at least some of your photographs. Hand-tinting adds charm and an heirloom look to black-and-white photos.

Are Premium Film Grades Worth the Money?

Not only do you have to pick the right film speed for the pictures you want to take, but some film manufacturers are now offering standard and premium grades of film in the same speed. This might seem like just a clever way for those companies to hoist another dollar or two per roll out of your wallet, but there is, in fact, a marked difference in the films. For example, Kodak now offers color print films in both Gold and Royal Gold packaging. The normal Gold film is excellent and may satisfy all your needs. The Royal Gold, however, is definitely more pronounced in color saturation and delivers less film grain. The difference between the two may be negligible in a 4 x 6 in. snapshot or in a photo made with a modest camera incapable of taking advantage of the better film. But if you want to enlarge your picture to 11 x 14 in. or create a panorama print, the difference in quality is certainly evident.

Again, take some pictures in identical circumstances with both films and see the difference, if any, for yourself. The processing cost is identical, so you only need to consider the initial difference in film price, which is usually just a dollar or two. You might choose the standard Gold film for your day-to-day snapshots and save the Royal Gold for special occasions or your three-week trip to Italy. Given the small difference in cost, we tend to choose the Royal Gold for almost all of our 35 mm print photography.

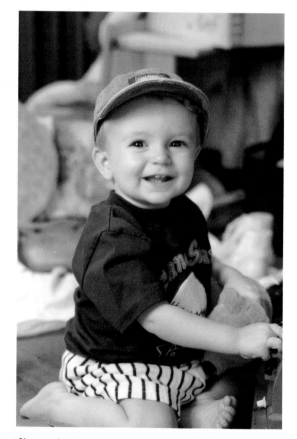

If busy colors in your photo overpower the child, try having it printed in black and white.

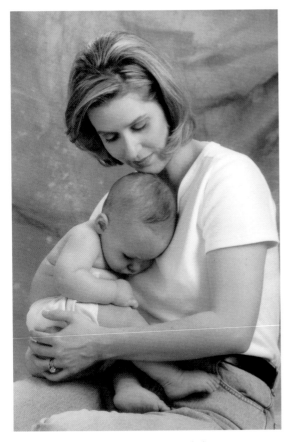

This intimate image, shot with window light against a painter's drop cloth, was given an old-time feeling by being printed in black and white. It was taken on Ilford XP-II chromogenic film and printed on normal color paper.

and-white prints from color technology. Ilford XP-II, Konica VX Pan-400, and the newer Kodak T-400CN allow you to take pictures just as if you were shooting with any other ISO 400 film (technical specifications are available from the manufacturers). Then you send this film to your local lab, and what comes out of their automated, color processor is a black-and-white image. These films make black-and-white photography as easy and affordable as color, and they can be very easily printed by your local photofinisher in a beautiful warm sepia tone reminiscent of old-time photos. Some of these films are now available even in dis-

posable cameras—a painless way to try them out. We love this kind of film. It tends to be pretty low in contrast, but that makes it very easy for the local film processor to produce an acceptable print. And, like color print film, these chromogenic films are very tolerant of poor exposures. All the ones we've mentioned here produce lovely results, but we personally prefer the Kodak, as it seems to have a little more "snap," or contrast. You might prefer the Ilford because of its softer quality.

You can also take any color negative to a commercial lab and have a black-and-white print made of it. Printed on Kodak Panalure or Ektamax papers, it will not have the archival quality or tonal range of a print made on true black-and-white paper, but this is an excellent way to get a black-and-white print from a color image. Conversely, if you have a stack of old black-and-white negatives lying around, take them to the local photofinisher to be printed as black and whites on color paper—a much less expensive alternative to sending them out to a costly custom lab. The technician may have to print them two or three times to eliminate the color cast common to these automated printers, but it really can be done by a photofinisher who cares enough to do it right.

Don't be afraid of black and white, even if you don't like your initial results. Some images really lend themselves to the medium, and it adds great variety to your repertoire.

Infrared Films
This is the most peculiar film you will ever shoot. Available mostly in black and white, it records an image in "unnatural" shades of gray—for example, taking dark green leaves on a tree and rendering them snowy white. This curious film can achieve truly surreal, dreamlike images.

There is no ISO rating for infrared film. Why?

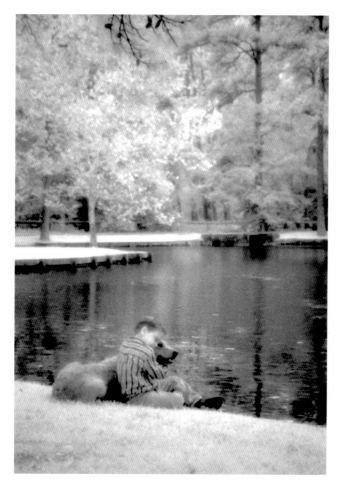

When properly exposed with a red filter, infrared film produces strangely beautiful images.

Because this film is sensitive to a part of the light spectrum (infrared wavelengths) that your camera's light meter doesn't register. This terrifies numbers-oriented photographers who require a figure and a technical formula for everything. You will also note in the instructions that the film must be loaded into your camera and unloaded back into its light-tight plastic container in complete darkness. Believe these instructions!

To acquire the desired effects, you must use a red filter over your lens when shooting this film. Even weirder, you must also focus just a little short of what you think is the correct focus point, because this wavelength of light travels through your lens and focuses differently than visible light.

Most full-featured cameras have a mark on the lens showing you where to adjust your focus for infrared film. Using a small aperture, like f 16 or f 22, on a wide-angle lens will ease your focus worries; this will give you an extensive depth of field.

Since you can't measure the infrared light in a scene in any practical way, just consult the data sheet packed with the film and *bracket* your shot; with luck, one of your exposures will be within the range of "printability." Experience will certainly help refine your technique as you shoot more and more of this unusual film. It's not designed to use at birthday parties . . . it's a fun, dreamy film, which is enough of a good reason to take it out to the park one pretty day and fire off a roll or two.

Instant Films

Instant films, available only from Polaroid Corporation, are another entertaining film with which to experiment creatively. They require the use of a Polaroid camera, since Polaroid stringently enforces its patent for instant-film technology. But with the advent of disposable Polaroid cameras, anyone can create instant memories without the expense of purchasing an additional camera. Kids, in particular, love these pictures, probably because they generally prefer instant gratification to having to wait for anything. You can also take a quick Polaroid test shot of a scene to make sure it's what you want before you go through a whole roll of conventional film. (Professionals use Polaroids this way all the time.)

Unfortunately, a Polaroid photo does not give you a negative from which to enlarge your pictures or make copies, but you can always have the shot scanned and printed digitally, if you like. This film doesn't achieve the technical quality of a good 35 mm image, but it is fun, quick, and entertaining.

Understanding Grain

Grain is the physical characteristic in film that we usually don't want to see. As the silver-halide particles in your film's emulsion come together in developing, they form little clumps, which result in a graininess in the pictures. Grain can make a soft baby face look rugged and old. As a rule, the higher the ISO and the more the film is enlarged, the more grain the final pictures will have. Not too long ago, there was a noticeable increase in the grain "structure" as the speed increased. That has changed over the past few years, and now the increase of grain in a 4 x 6 in. snapshot from ISO 100 to ISO 400 and even some 800 films is negligible.

We did say we *usually* don't want to see grain. But some of the most beautiful photographs we have ever taken have been made with super-fast ISO 1600–3200 films. These are great for capturing soft, impressionistic images of children. The grain is so apparent that it gives the print almost a pointillist look.

If you have no plans to enlarge your pictures beyond snapshot size and particularly if you are shooting without a flash, in limited light, or concentrating on moving targets (i.e., two-year-olds), choose the ISO 400 and 800 films.

If you have any plans to enlarge your pictures for display later on, lean more toward the ISO 100–200 emulsions and figure out a way to keep two-year-old Johnny glued to his chair!

This beach portrait of Rick's family was taken on Kodak 35 mm ISO 1600 film. It is now a soft, grainy 20 x 40 in. wall portrait over the fireplace.

The Need for Speed

Choosing the correct film is a matter of both science and art. Often you have to make a choice between picking the best film for a particular subject—children at play, for example—and the specific lighting conditions of the moment. Photographers have begged the film manufacturers for high-speed film that produces vivid colors and natural skin tones without any visible grain. That demand has pretty much been supplied over the years, but you will still have decisions to make. This is where your own experience and artistic choice will come into play. In many cases, there is no one perfect film for a given situation, but here are some general guidelines to get you started.

Situation	Film Choice	Advice
Bright sunny day	ISO 100–200	With plenty of light, use the most color-saturated, least grainy film available.
Hazy to overcast	ISO 400	Select a more sensitive film that allows you to hand hold your camera without blurring your pictures.
Rainy days, dusk	ISO 400–1000	This allows you to shoot in natural light without a flash, but you pick up more film grain.
Sports/two-year-olds	ISO 400–1600	The faster films let you record faster action without blurring it.
Large-format prints	ISO 25–100	The lower grain in these films permits larger pictures to be printed with greater sharpness and more vivid color. In low light, use a tripod to reduce camera shake.
Telephoto pictures	ISO 400+	More light must pass through the longer telephoto lens in order to expose the film. Again, a tripod is a great accessory.
Everyday use	ISO 200–400	For an all-around film to keep loaded all the time in your camera, stick with an ISO 200 in a full-featured camera and an ISO 400 in a more modest compact.

Get instant results during creative moments by using Polaroid film.

Brand Names

Just as in shopping for anything else, you will have a few major brand names to consider in making your film purchase. We generally lean toward Kodak for our own pictures. We grew up with it. We have hardly ever heard of anyone encountering a serious flaw in it. It is tested and manufactured to reproduce skin tones and other colors in the manner most suited to Western eyes, which tends to be more natural and slightly less saturated than films formulated in Asia. To be sure, other companies headquartered in Japan, Germany, and elsewhere make outstanding films that are perfectly suitable to many uses. Our recommendation is to try several different films from some of the best-known manufacturers and see what makes you happy.

Pro Films

You may occasionally encounter a box of film with the designation Professional printed on it. These films come refrigerated from the manufacturer to ensure that the ISO speed remains exactly as stated. Other than this, there is no difference in quality between professional and consumer films.

However, there are small differences in the characteristics of these print films. The pro films are designed to accurately reproduce skin tones, so they tend to be a little less contrasty and color saturated. Some people prefer the livelier colors and stronger contrast of the consumer films. Because we are fanatic about natural rendition of human skin tones, we usually work with the pro films, and we encourage you to experiment with them. Many of the images in this book were created with Kodak Portra 160 and Portra 400 professional film. Just keep in mind that pro film is much harder to find and a little more expensive.

5. Photographing Indoors

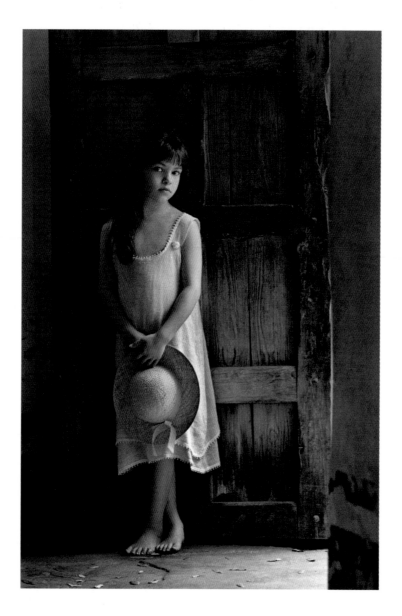

OK, you have your camera, some cool new accessories, and various films to play with. It's finally time to take a picture! We will start by exploring some ways to take pictures indoors—a place we can work no matter what Mother Nature has in store. We will begin by learning how to create some of the most beautiful of all portraits, those illuminated by natural window light.

A word of caution before you start: If you are taking the time to set up something nice and create some pictures "for keeps," check your film before you start. If you have only two or three shots

left on the roll, now is not the time to be a cheapskate. Find the button that will rewind your film in mid-roll and load a fresh roll. You would hate to miss out on a great series of expressions and poses while you were busy rewinding and loading film. The risk is just not worth it. And remember that with many APS cameras, you can reinsert that first roll right back in at a later time. The same can be done with a traditional 35 mm by simply making a note of the frame number, replacing it in the camera, and shooting up to that number again with the lens cap attached. You might advance one extra frame to insure against any overlap.

Window Light

Window light is a great source of illumination. It was used by the magnificent portrait painters of the Renaissance, and it was the primary light source employed for indoor portraits by pioneering photography studios before the advent of electricity. It is a lovely light and, best of all, it is free and available to us all. It is easy to use and also easy to misuse. We will show you here how we use it every day while photographing children in our studios. (Keep in mind that what we call "window light" could just as easily be coming through any open door or porch.)

The ideal window light would be gently pouring through a window on the north wall of a building (assuming you live in the northern hemisphere). In that case, you wouldn't have to fret over too much direct sunlight blazing in and ruining your picture, but at the right time of day, any window will do. Even when harsh, direct sunlight is pushing through, you can use white curtain sheers or some other means of diffusing and softening the light.

Generally, you are going to place your camera (loaded with film in the range of ISO 400–800) at one end of the window and position the child at the other end, either facing the camera or maybe looking outside. Turn off any room lights for now. The most important thing to strive for is nice lighting reaching into the child's eyes. If she is turned too far away from the light source (the window) or is placed too far from the window and toward the camera, precious little light will find its way into her eyes (see diagram, next page). As a result, there will be no sparkle in her expression. Gently adjust the child's position either forward or back and turn her head from side to side, all the while observing the quality of light on her face and in her eyes. (Obviously, this exercise is easier to practice on a well-mannered ten-year-old child than a squirmy two-year-old.) Once you learn to recognize the most pleasing quality of light on a face, you will immediately begin to be a more successful photographer. Just don't expect that to happen overnight.

If you have trouble seeing the effect of various lighting angles on the child's face, go through the same movements described in the last paragraph while you take pictures, then study the photos later. Look for differences in the luminosity in the eyes and for the way the light shapes the face. We show you some examples here to give you an idea of what to look for, but it is much more enlightening to experience this process with your own child and your own equipment.

Once you begin to understand what you are looking for with window lighting, get out that reflector you made with aluminum foil and white spray paint, back in chapter 2. Have a friend or parent hold it just barely out of camera view and just in front of the child at the window. Move it around until you can see it bounce some light back onto the child's face. Try it using each side at different angles, high and low, all the time watching the

Photographing with Window Light

Sun

Window

Position 1. Notice the beautiful soft light falling across the little girl's face, producing soft highlights on one side of her face and excellent detail on her shadow side.

Position 2. As she moves forward, we still have the nice highlights but begin to lose detail in the shadows. Sometimes this can create a nice mood-lighting effect, but here all the sparkle in her eyes is lost.

Position 3, pictures 1 and 2. As she moves even farther forward, the shadow side goes very dark. When she turns her head toward the window, only the "mask" of her face is illuminated. This is a lovely way to light her face and draw attention to her expression.

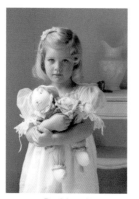

Position 1

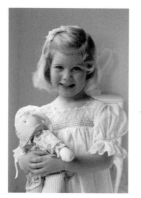

Position 2

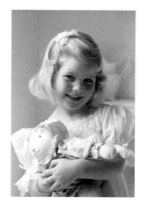

Position 3, picture 1

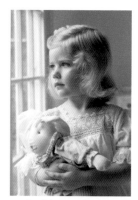

Position 3, picture 2

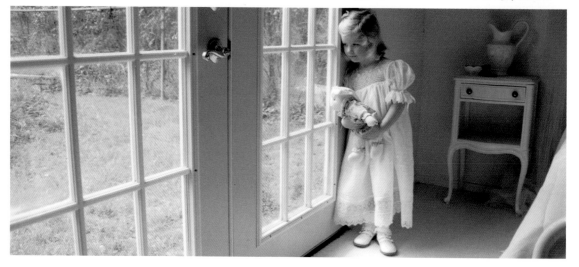

"The Last Silver Bullet"

Telling a story while capturing the personality of the child makes the photograph more interesting. This boy's room is decorated with a Lone Ranger theme, so we decided to capitalize on that when we created this portrait to hang on his wall.

The photograph was shot in the attic with 1000 speed Kodak film. The light on the boy's profile (known as "rim light") came from a window at the right corner of the photograph. A silver reflector next to the camera was used to fill in the shadow areas of his face and the front of the trunk.

child's face and seeing the sometimes beautiful, sometimes not so beautiful effect it produces. The light bouncing off your reflector will also lower the contrast ratio, which is the difference in the amount of light on the window side and the room side of the face. A reflector can produce a more balanced lighting, but if overdone it can also dash the mood of a delicate image.

You might think it would be better just to turn on a lamp and use that rather than the clumsy homemade reflector. The problem is that the light

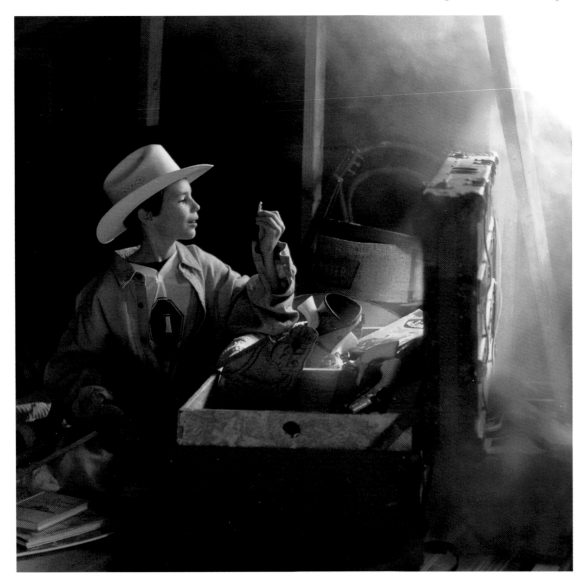

being produced by the bulb is much warmer in color than the relatively white light entering the window. Sometimes that warm glow on the shadow side of the child's face can be really interesting and atmospheric, and sometimes it just looks orange. This color effect is much more pronounced with slide film than with print film, but it's no problem at all if you are working in black and white.

We refer to this extra light, whether from your reflector or a lightbulb, as the fill light, illuminating and defining the skin on the shadow side of the child. One way to circumvent the lightbulb dilemma is to purchase a daylight-balanced blue lightbulb, which will eliminate the orange glow. Again, try it and see what looks good to you. After all, this kind of experimentation is another of the fun things about photography!

Selecting the right lens for a window-light photo is a pretty simple decision. If the background behind the child is her carefully decorated room or something else you want to include, use a wider-angle lens, which will "see" a larger area in the background. If the background is cluttered or unimportant, use a longer lens. Remember that the longer focal length not only sees a smaller area of the scene but also helps to throw the background out of focus, directing attention back to the child.

Using Your Camera's Built-in Flash

The fact that you can set your camera to one of several flash modes and it will automatically give you a good picture is just amazing to those of us who started out with flashes that required consulting ISO-to-distance tables and manually calculating the flash intensity. Generally, when you take pictures indoors without the benefit of natural light pouring in through a door or window, you depend on the flash that is built into your camera. What you will soon notice is that the beautiful window lighting you just learned how to use is impossible to re-create with a fixed built-in flash. Basically, these flash units are designed to give you the right amount of light to make a proper exposure. There is nothing particularly artistic about them, but they do their job.

Indoor flash photography can often be improved using an easy little trick known as "dragging the shutter." You can do this only if your camera allows you to adjust your shutter speed manually. Most cameras give you a standard shutter speed—say, 1/60th or 1/125th of a second—to use when working with a flash. But if you use that speed, too often the background behind your subject goes very dark or black, especially in a dark room. To obtain more detail in the background, just adjust your shutter speed to take the same picture at 1/30th of a second, or even 1/15th of a second in a really dark room. You'll be amazed at the difference in your pictures. Remember that this technique is for photos taken in a dimly lit room and is most effective with faster films, such as an ISO of 400 or 800.

Avoid placing children too close to a background wall; otherwise, your flash is likely to produce a hard shadow right behind them. Also, be very careful not to photograph into reflective backgrounds, such as a mirror or window, which will send your flash right back into the lens in a big white blur. Often you can leave the children where they are and adjust by moving yourself into more of an angle to the window before taking the shot.

Flash units do have a limited range. For any given film speed (ISO), your flash has a minimum and maximum distance that it can be placed from your subject to achieve proper exposure. Also, your state-of-the-art compact point-and-shoot may

Photographing this birthday party with different shutter speeds produced some amazingly varied results.

Flash and a 1/15th of a second exposure

Flash and a 1/30th of a second exposure

Flash and a 1/60th of a second exposure

Automatic flash and a 1/90th of a second exposure

The picture below was shot with available light, no flash; the warm, golden light comes from lamps and overhead light, with a little help from the birthday candles.

Some Creative Options for Artificial Lighting

A normal light bulb placed in a lamp or in a reflector will give a warm, amber glow to your photographs.

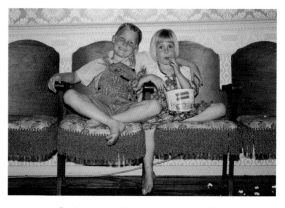

A separate flash mounted on the hot shoe of the camera usually eliminates red eye.

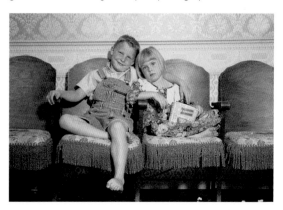

A blue daylight-balanced bulb can be used instead of a flash. These bulbs produce reliable, natural-looking results.

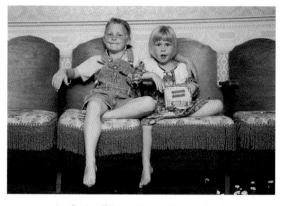

Bouncing the flash off the ceiling yields a soft, pleasing light with no shadows.

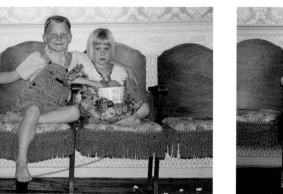

A built-in flash is more convenient, but you're liable to end up with the red-eye problem.

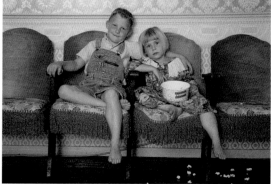
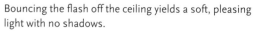

Turning the flash around and bouncing it out of a corner behind the camera creates a nice big bank of soft light.

feature three or more automatic flash modes to consider. Consult your manual about all those modes (some useful, some not). Take care that random objects closer to the camera do not receive the full effect of the flash, or they will become much brighter than your subject. The farther away your subject is and the slower the film you use, the slower the recycle time will be on your flash, for it must produce a full blast of light each time and then go through a complete recharge cycle. Finally, make sure you are aware of your flash's location on your camera. In less thoughtfully designed point-and-shoot cameras, and especially on disposable cameras, it is very easy to place your finger carelessly over the little flash in your eagerness to take a picture.

This might be a good time to stop, take a deep breath, and ask yourself if you understand what you just read about lighting. As you learn more about photography, all of this will become second nature, but it may seem overwhelming at first. If you are still unclear, just back up and read through it one more time. Many of these topics overlap, so you'll see some of the same concepts discussed later in the book from a different perspective, which will help these ideas fall into place.

Working with a Remote Flash Unit

Working with a remote flash unit operated as a separate entity from the camera, rather than a built-in flash, you can begin to create beautiful, flattering lighting again. You can point the remote flash in various directions, bounce it off different surfaces, and create effects impossible to achieve with a flash fixed into the camera. In our studios, we do not use the automatic settings on our flash equipment, preferring to take light readings with professional light meters so we retain complete control of the exposure. But in this book, we will show you how you can use your automatic flash

units to create terrific images every time. Even if you want to master the manual operation of your lighting later on, this information will give you a terrific head start.

For starters, let's talk about the effects of bounce lighting. This is simply the technique of bouncing your flash off an interior wall, ceiling, or even a reflector to produce a soft, pleasing light. Two things must be kept in mind when using bounce flash. First, the electronic light sensor (or electronic eye) that is built into your flash unit must be kept aimed directly at your subject. It reads the light bouncing off your subject and tells the unit how much power it needs to produce a correct exposure.

Second, make sure you don't bounce your light off a colored wall. Even a pale tint will cast an unusual color on your subject. And light bounced off a green wall will promptly turn your child into a Martian! Make sure the bounce flash is powerful enough to bounce all the way to the child; the brighter the wall or ceiling, the less power you will need. Many flashes come equipped with a little green LED light telling you that enough light was created to produce the desired exposure.

If a white wall is unavailable or too far away to bounce back sufficient light, get that little reflector back out and bounce your flash onto it. Using the reflector requires another set of hands or a support stand of some sort, but it does let you control exactly the origin and direction of your light. You can also either bounce light off a bedsheet or aim the light directly through the sheet, as long as your flash's light sensor sees the child and not the sheet. Finally, if your flash head can swivel 180 degrees, you can go to the camera store and purchase a light stand and a photographic umbrella with the appropriate hardware and adaptors specific to your flash and direct your light exactly where you want it. Be sure to get the hang of simple bounce

Window light nicely illuminates a moment shared by friends.

flash before you decide to spend the money on more equipment.

Where Do I Put the Children?

Setting and background can be very important in telling a child's story through a photograph. A child's bedroom, for example, often has several elements that reveal his personality. A shot of him curled up on the floor beside a fireplace in the living room will create another kind of feeling. And one of him baking cookies in the kitchen with Grandma can tell an entirely different story.

Think of things a child or group of children might enjoy doing indoors, a project that would reveal aspects of their personalities. Encourage them to become involved in this project. It's amazing how creative you can be with kids. Once you determine a possible project, figure out the right setting and props to make the child comfortable. Select a camera angle that minimizes clutter and distractions in the background and takes full ad-

Dragging the Shutter

Most better cameras come with an indicated "maximum shutter-sync speed" recommended for your flash photography. Shooting with a shutter speed any faster than that will close the shutter curtain before the flash has finished firing, resulting in a picture that has only one half exposed correctly and the other half virtually black.

Now, if this speed is listed at 1/125th of a second, for example, there is no reason why you can't select a slower shutter speed of, say, 1/30th of a second or slower. Here is what happens. The camera's shutter opens and the flash fires immediately, lighting up the children directly in front of your camera. But as the shutter stays open that full 1/30th of a second, it al-

lows four times the ambient light in the room to reach the film. As you can easily see in the photos shown here, we can record much more room detail with the slower shutter-sync speed. Remember that this works best in a darker room.

But first you have to ask, "Do I really want more detail back there?" If you are photographing a flower girl at a wedding reception and you want to see all the beautiful room decorations and flowers, you certainly do. If you are taking a picture of a child in a room filled with meaningless clutter, you probably don't. Once you understand the technical principle, you can make your own decision about how to use that knowledge to help solve the problem creatively.

vantage of any nice natural lighting that may be coming in through a window or door. Since you are indoors, choose a faster film that lets you keep the child in focus while maintaining some detail in the darker nooks and crannies of the room. Finally, dress the children in clothing that both reflects their personalities and maintains a color harmony with the setting. Then you can all just start having fun. Shoot some film, trying different framing, compositions, poses, and expressions. When you reach a point where you can stop thinking about the technical side and focus all of your energy on the creative side, then you can really start making great pictures of children.

Props

So you have the setting, background, film, and lighting all figured out. Now what is the child going to do that is special enough to justify all this time and effort? This is when picking out some meaningful props can be inspiring for you both. As with so many other tasks, the more fun you make the picture-taking session for the children, the more fun they will make it for you. And props are the number-one way to make picture taking

Place your subject right in the middle of his favorite possessions for a great storytelling portrait.

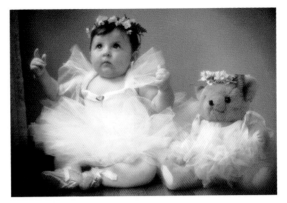

When selecting props, look for classic, untrendy objects that won't date your photograph later. The color of the prop should harmonize with the background and the child's clothing.

more fun than just grabbing a snapshot.

Of course, all your child really needs to do is to sit up straight and look at you with that wonderful little smile, and you'll have a portrait to treasure. But pictures are even more fun to look at when they make a more personal statement. Maybe your son is smiling at you while hugging his teddy bear, the same teddy bear that happened to be yours when you were his age. Maybe your little girl is playing dress-up in your very own wedding gown for an audience of your collection of Madame Alexander dolls. It can be especially nice to give Grandma a portrait of her granddaughter wearing the necklace she gave her on her fifth birthday. (Keep in mind that family heirlooms and special gifts to a child are great, but only if you don't have to worry about damage control.)

Not all props are ideally suited to photographs. Props featuring bright primary colors tend to pull attention away from the child. But Lincoln Logs on a hardwood floor, for example, are a timeless classic and blend into the scene without distracting. Or picture a little boy surrounded by his toy trains and wearing the conductor's hat his grandpa gave him. Whatever you use, try to harmonize the color of your props with the clothing and background colors.

Creating Your Own Home Studio

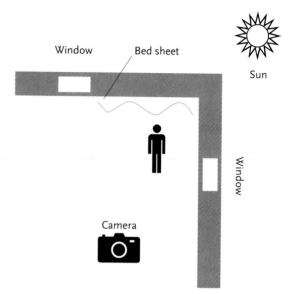

This lovely portrait could have been created at a studio but was actually taken in a garage with two windows. Notice how the front window illuminates the face and the back window lights the hair, distinguish-

ing it from the bedsheet used as a backdrop. The sheet can be made lighter simply by moving it closer to the front window.

Creating a Studio Look

All right, we know what you want. You think you can just read a book like this and then go create a portrait that looks as though it were done in a professional studio. OK, here's how to do it.

Find a place in your home with plenty of beautiful window light. Pin a pretty bed sheet or layers of lace or linens to a wall in the background and softly drape the fabric down over the floor and outward from the window. Ideally, this would be a big wall of light from patio doors or the like—the bigger your light source, the better. Place the child

anywhere in the scene—standing, sitting, whatever you like—and start taking pictures. You will, with a little luck and perseverance, create some beautiful images just like those you might get from a professional studio. You are not going to create consistently beautiful studio-quality portraits every time, but you will undoubtedly be quite happy with the results. You can create as elaborate a setting as you like, as long as the window lighting will illuminate most of it.

Lenses, Shutter Speeds, Apertures . . . the Scary Stuff

After all the thought and planning about lighting, clothing, props, and composition, you're finally ready to start photographing, but you may need to make some technical decisions first. If you are taking pictures with a disposable or a compact point-and-shoot camera, just start clicking and having fun. If you are working with a camera that allows manual control and a choice of auto-exposure modes, here are the basics you need to know.

Let's start with lens selection. We can give you some general guidelines and principles, but once you understand the characteristics of different lenses, selecting which one to use is a very personal decision, based on your own perceptions and preferences. Longer-focal-length lenses, over about 85 mm, tend to have shorter depths of field, which means they focus on a narrow range of the image and throw the rest of the picture out of focus. This is great when you have a busy background and want to downplay it. Longer lenses don't see as much; they don't capture much of the area surrounding the subject, which again makes them great when you want to eliminate distractions. They also tend to be slower, needing more light to take a photograph than a normal or wide-angle lens. Telephoto lenses are more susceptible to camera shake and so are better suited to use on a tripod. It's a good idea to select a faster film when using longer telephotos. One big advantage to a longer lens is that you do not have to move in as close to your subject, making it much easier to capture a candid moment with the child totally unaware of the camera.

Wider-angle lenses, with focal lengths of about 35 mm or less, tend to see lots of whatever surrounds the subject, and so they make wonderful choices for environmental images in which you simply let the child interact with his setting. Because they also have a larger depth of field, most of the scene will appear in sharp focus, whether you want it to be or not. This is helpful with group shots in which not all the faces are the same distance from the camera. But close-up photographs taken with a wide-angle lens have a tendency to distort the subject, making a child's face appear wider than normal. Most of the time this effect isn't very flattering, but occasionally it is fun to play with.

To sum up, longer lenses are best suited for portraits as we defined them back in chapter 1, whereas most environmental images are most easily made with a wide-angle lens. That is a general rule of thumb, and you have our permission to break it any time you wish, as long as you have a good reason to do so and you are having fun with your photography in the process.

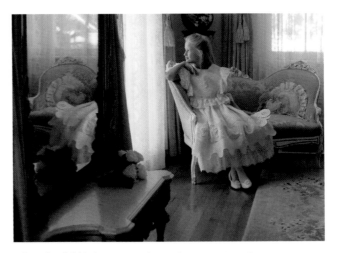

When the child is in an attractive environment, try using a wide-angle lens (35 mm or less). Since wide-angle lenses have a larger depth of field than other lenses, you will be able to maintain more sharpness in the foreground objects while also creating more depth and perspective.

6. Let's Go Outside!

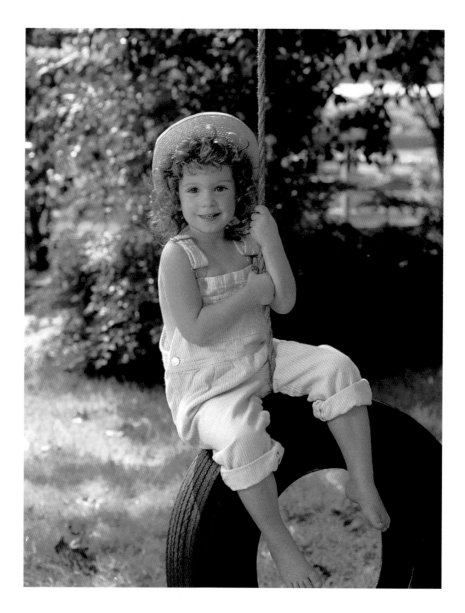

Taking children's photographs is probably easier outside than in because we have that great natural light source called the sun. Children usually love to go outside and play, and you can make the picture-taking process a big game for them. The breeze is blowing, the flowers are blooming, and the sky is the limit on your creativity. This chapter will help you figure out the best settings and the best lighting. We will recommend some activities and props, and we will also give you some pointers for taking better pictures on your vacations and family outings.

Photographing children in favorite settings will help you capture a sense of their personalities.

Selecting the Right Spot

Finding the right location is the key to making great pictures of children outdoors. Is there always one perfect location in which to shoot? Of course not. Picking a location is one of the many choices that will distinguish your photographic style from that of your friends. We have noticed several times in the course of creating this book that the two of us had very different ideas about where to place a child in a setting. These differences have allowed us to learn from each other as well as to help you along your own creative path.

Does the child have a favorite place to play? A little girl might cherish a particular park bench where Grandma reads stories to her. Or maybe she enjoys having a tea party on the porch with her fa-

vorite doll. A boy might have a secret nook beside the barn or a pond where he enjoys fishing with his friends. Sometimes it is rewarding to think of a child's photographs as a gift not to their parents but to him forty years from now. Imagine the grown-up child showing these pictures to his own children and telling them how a particular setting played a memorable role in his childhood. Pictures can contribute so much more to our lives than simply documenting how incredibly cute we once were.

Find or create a setting in which a group can relax and be comfortable—enjoying a family trip to the zoo or washing the dog or whatever else they might enjoy doing on a fine sunny day. Select a spot with few distractions in the background. Think about color harmony. Do the colors in the scene harmonize or clash with the children's

Keep your eye out for interesting architectural backgrounds. Universities and churches are some of our favorite places to shoot.

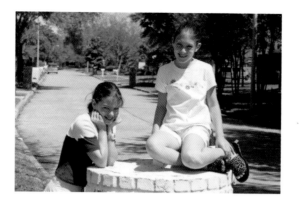

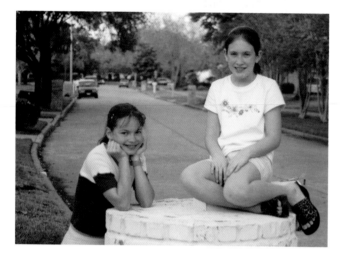

Top: Noontime sun ruins this candid picture by creating squints and harsh shadows.

Bottom: Wait for a cloud to soften the sun's glare or, as in this case, come back to the same spot just before sunset and create a softer, more evenly illuminated picture.

outfits? If the latter, change the setting, change the clothing, or consider pulling out your black-and-white film.

Once you've decided where you are going to take a picture, you should start considering the quality of the natural light already on the scene. In fact, many professional photographers have trained themselves to look first for the most beautiful lighting in a potential location and only then select the final place to work. That is how important good lighting is. Let's talk about the possibilities you are most apt to encounter on a typical day at the park.

Bright Sunny Days

It's hard to beat a beautiful sunny day to lift one's spirits. But for portraits, that bright light is often the most difficult to photograph. However, if the kids are doing something incredibly cute right now in the dazzling sun, they usually won't wait for nature to create more flattering lighting. What can you do?

The sun is an enormous light source, but it is so far away that it acts like a tiny "point source" of light (just like your camera's flash), creating bright, harsh lighting accentuated with dark, hard shadows. (That is all the physics you need to know right now.) Children's eyes are more sensitive than ours, and the intensity of the sun generally makes them squint, which obscures their beautiful eyes and ruins their sweet expressions.

If the sun is high in the sky, the eyebrows and forehead block the light, causing what we often call "raccoon eyes"—dark shadowy eye sockets that make the face look sort of like a raccoon's. Color film can record only a limited range of brightness, so if the lab tries to print for good skin tones in the shadowy areas, all of the highlight areas in the picture will be "washed out," turning pure white. If the lab instead prints for detail in those highlights, then the shadows will "block up," turning jet black and making the image look even harsher.

Fortunately you have several solutions to consider, and the right one is entirely your own choice. First, consider taking the picture at a different time of day. The light within an hour of sunrise and sunset—what is lovingly called "golden light" by photographers—is beautiful even on a cloudless day. Instead of shooting in full sunshine, maybe you can go inside for a while, have a nice cool drink, and come back out a couple of hours later to find a totally different

quality of light. Or, scan the horizon and see if a nice, big, puffy cloud might be coming along. A cloud will function just like a huge photographic umbrella, softening the bright points in the photo (the highlights) and filling in detail in the dark areas (the shadows).

Maybe it's too sunny but you're already out there with a little girl all dressed up and ready to go. You've got other things to do soon, so if the light is going to remain harsh for a while, you have to learn how to modify it. Here are some of your options. Find a setting where you can place the

child out of direct sunlight but still keep the look of a nice sunny day. For instance, put her on a blanket under a tree or up under a porch awning. You retain the sunny feeling but the child's face is illuminated only by the softer, gentler reflected light bouncing in under whatever is shading her. If not enough light is reaching her in the shade, grab that reflector again and bounce a small, controlled amount of sunlight back into her face. Try the white side first—in full sun the aluminum-foil side might be painfully bright.

Can't find any existing overhangs to tuck the child under? Grab that reflector again and have someone hold it directly over the child's head,

Top left: This picture shows the effects of shooting in bright sun: washed-out highlights and squinting eyes.

Bottom left: When a cloud blocked the direct sun, the entire mood of the scene changed. We simply backed up a little and allowed the child to be a child.

Right: When a magic moment happens, don't overanalyze—just take it!

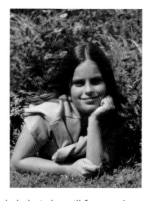

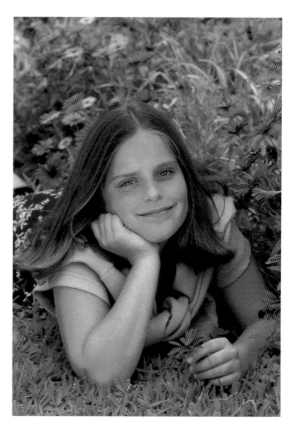

If the sun is directly overhead, dark circles will form under the child's eyes and the light will look very harsh (above). For a softer, more natural effect (right), try blocking the light by holding a scrim over the child's head and filling in the eyes with light from a reflector.

blocking out the direct sun. When we use a reflector to block instead of reflect the light, we usually refer to it as a scrim or a gobo.

You may need to move in a little closer physically with the camera or zoom in with your lens to crop the reflector out of your frame, but you will dramatically improve your lighting. If you don't like completely subtracting the sunlight, you can stretch a white sheet over some sort of homemade frame and use that in place of the reflector. This will allow diffused sunlight to illuminate the child's hair and give it a nice soft glow, rather than killing the light with the reflector or just allowing the full light to wash out all the highlights to pure white.

Say you like the sharp highlights created by direct sunlight on black hair. Then use the reflector to bounce some raw sunlight back into the child's face; this will eliminate the raccoon look and allow her face to receive an amount of light comparable to that in the background. Make sure, though, that your reflector is not making her squint. Another option is to use your flash to produce the same effect, which avoids having the child squint into a reflector. This is hard to do consistently without a professional light meter, but many of the newer

cameras have a fill-flash mode designed for just this type of exposure when you are working with a strongly backlit subject. This is obviously much easier than carrying a reflector panel around with you. (The advantage of the reflector, though, is that you can see the effect you are going to get before you shoot.) Even though you may think of your flash as only a tool to light up a dark scene, you have to trust us on this one: it really does improve a photo on a bright sunny day, if you are close enough for your flash to have any effect.

You might also place the child near a bright white wall or even park a white car beside him to use as a big reflector. You will also notice that on a white sand beach, raccoon eyes are automatically corrected by the light bouncing up from the sand.

Another possible use for a reflector is to hold it over your lens to block direct sunlight. An easier solution is to purchase an inexpensive lens shade to keep installed on the front of your lens, if there's

When bright sunlight is beating down on the child (above), you can use a white sheet or a round diffuser (available from camera stores) to soften and direct the light (right).

a space for it. If your camera cannot be fitted with a lens shade, just block the light with a spare hand or try to stand in the shade while you shoot. Otherwise you risk disastrous flaring effects or distortions as stray light strikes the lens surface.

Cloudy and Overcast Days

Cloudy days cause fewer problems with squinting and harsh light, but they present their own challenges, which you will also want to learn how to handle. Unlike the strong, focused light of a sunny day, on cloudy days the light seems to come from everywhere and nowhere. Since there is no obvious direction of light, an uncontrolled snapshot will look flat and dull. And if most of the light is coming from above, your subject can still end up with raccoon eyes. Here are some simple methods to control and improve your photos on a cloudy day.

As previously mentioned, some automatic cameras have a fill-flash mode. This gives the picture some snap and contrast while filling in the eye sockets with light. In a pinch, this is a quick and easy lighting solution. As described above, you can also look for a porch or other overhang to take pictures under, creating a gentle directional light. In the shade on a cloudy day, make sure to

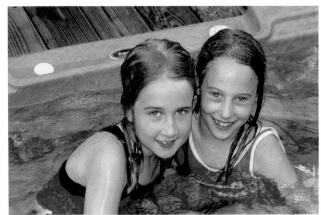

Even on cloudy days you'll likely end up with "raccoon eyes," since most of the light is coming from overhead (bottom). By using the fill-flash mode on your camera, you can fill in the eye sockets with light and add snap and contrast to your image (above).

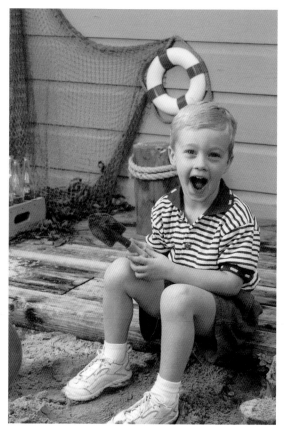

Above left: Overcast natural light coming mostly from above makes the image flat and gives the boy "raccoon eyes."

Left: Using a built-in flash adds some snap to the picture and softens the eye bags, but it also creates harsh shadows behind the boy, increasing the overall washed-out effect.

Above right: Eliminating the flash and using a silver reflector off to the side produces a nice, soft three-dimensional image with lovely light in the eyes and no harsh shadows.

have faster film in the camera, in the ISO 400 range, which will allow you to use a fast enough shutter speed to keep the child in focus.

A cloudy day also offers a great opportunity to put the silver side of your reflector to use. Since it is not reflecting direct sunlight, it will direct a soft light into the child's face that can bestow a beautiful portrait quality. If the day is too overcast to generate enough light from the reflector, you will probably have to resort to a flash unit. If you have purchased equipment that lets you use a remote

flash unit, you can create the same sort of portrait lighting described in the chapter on photographing indoors.

Sunrise, Sunset

This is the "golden hour" for making photographs, when you can obtain beautiful images with almost any camera equipment. The light has a soft, warm quality that gives the skin a nice healthy glow. (It looks even warmer in areas with lots of air pollution or active volcanoes, but this is optional.) Children can look right into this light and not squint. Of course, children may not give you their best expressions at sunrise, and if you're not a morning person, you may not be awake enough to care. But just about everyone can be happy at sunset.

Basically, just make sure the children's faces are looking in the direction of the glowing horizon to ensure that their eyes are nicely illuminated. And that's it—it's that easy. With a tripod, you can shoot well into the sunset hour with slower shutter speeds, assuming you are not chasing a two-year-old.

This is also a great time to create some wonderful silhouette portraits set against a beautiful sunset. How do you create a silhouette portrait? Just pretend you are taking a picture of the sunset without anyone between you and the sun. Point your camera into the heart of the sunset and depress the shutter release halfway down, allowing the camera to read the light levels of the sky. Then move the camera to recompose your image with the child silhouetted in front of the sky and take your picture. If the sunset is not as spectacular as you would have hoped, place an orange filter over the lens and watch it come alive.

This dramatic photo was taken by placing an orange filter over the lens and exposing the film for the midtones in the sunset. If you're making an important picture, take the time to bracket, by shooting additional frames set at an f-stop or two up and down from your first choice.

If a child is having fun or doing something cute, don't make him stop and pose. Instead, savor the spontaneity.

Sometimes a child's expression is more important than having the perfect background or ideal light.

Easy Outdoor Tips

This section is designed to help on vacation, at a family picnic, or just in the backyard, when you want to take some casual family pictures with your point-and-shoot camera without getting too involved with technique. Just follow these steps:

♦ Place your subject in a location where there is little to distract the viewer and the light on the face is pleasing. If the subject can't be moved, then move yourself to find the best angle.

♦ If a child is having fun or doing something cute, don't tell her to turn around and say, "Cheeeese." Just capture her being herself.

♦ If the background is not important, come in closer and position the child in an interesting way within the frame.

♦ Make sure your camera is in the correct automatic-exposure mode, if applicable, and pick a lens length that makes sense, given what you have learned in this chapter.

♦ If you have manual exposure controls on your camera, decide what is the most important factor in the picture. Do you need a fast shutter speed to freeze action, a wide aperture to keep the entire field of view in focus, or a small aperture to blur out all but the child herself? Quickly set your camera accordingly.

♦ If you have time, try both horizontal and vertical compositions as well as different camera angles, both high and low.

♦ Hold the camera steady and gently press the button to avoid blurring your photograph.

When something cute, funny, major, or amazing is happening, sometimes all you have time to do is point the camera and let your instincts and your automated controls take over. The ultimate advantage of the sophisticated new equipment is that you can basically pick up any modern camera, turn it on, point it toward a subject, and take a usable picture. It's a good idea to keep your camera set in one of its automatic modes all the time in case you need to grab a great shot. If time permits, you can also take a moment to think about reflectors, flashes, lenses, filters, and all the other valuable new tools you have learned to use. Don't miss a "magic moment" by thinking too much before you capture at least one shot of it on film.

Even in a crowded park, you can make wonderful unclut-
tered photos of children. This image was taken with a
200 mm zoom lens at its largest aperture (f 2.8) to force all
the other distracting elements out of focus, keeping the girl
as the central theme.

7. Photographing Babies—
How Hard Can That Be?

It's our guess that one of the main reasons people will be taking this book home from the store is that they have a new baby in the house and want to learn how to photograph its every move. Babies are special. And knowing that they grow up so soon, we want to capture all their expressions and first experiences while they are still small. If you are photographing your own baby, you already know that there is no such thing as a bad picture of your own little bundle of joy. Let us show you some easy ways to create even more beautiful memories of your child at this special time.

For the purposes of this chapter, we will consider an "infant" as any baby that can't yet sit up unassisted. Because babies are helpless and utterly dependent upon you, you have only a few options for posing them. The baby can lie down on its tummy or on its back, it can be propped up in the corner of a chair or cushion, or it can be held by an adult or older child. Actually, you do have one other option, which is one of the most difficult propositions in portrait photography: to have the infant supported by a sibling who happens to be a toddler. More on that later . . .

Baby's Clothing and Surroundings

We recommend soft, natural settings for infant portraits. This is not to say that you can't wrap a baby up in Dad's Harley bandanna and put him on Dad's black leather jacket with cool shades over his eyes, but that probably won't be a favorite of Grandma's (unless, of course, she's a biker too). More classic settings include old-fashioned strollers, pretty baby cribs or daybeds, and blankets or quilts, propped with soft, fluffy pillows. Often, parents will want to feature a quilt, pillow, or blanket handmade by a grandparent or a special friend. Some even have the baby's name sewn into the pattern, which is a really nice touch, especially when photographing identical twins!

We tend to keep infant clothing to a minimum. There is very little in the world as delightful as a baby's toes and fingers. They do the cutest things with them, and it's a shame to cover them up with clothes or shoes, which are usually too big and bulky anyway. What could be more adorable than a cute little baby's bottom in a softly lit portrait in the nursery or bathtub? Remember that a baby's private parts are private, but a blanket or a bath toy can be strategically placed when necessary.

Using a special quilt adds a personal touch to this simple window-lit image of mother and child.

If you want to make a dressier baby picture, christening gowns and other special outfits are great options. Dressing babies in outfits made specially for them or once worn by their own parents adds a touch of nostalgia and charm.

Ideas for Posing Infants

Posing an infant is no different from posing any other child, in that we look for a setting in which the child can feel comfortable and amused. That

This baby needed a little help sitting up, but he gave us a great expression in return for our patience.

This baby's daddy is a guitarist. Including dad's guitar made this a very special portrait for him.

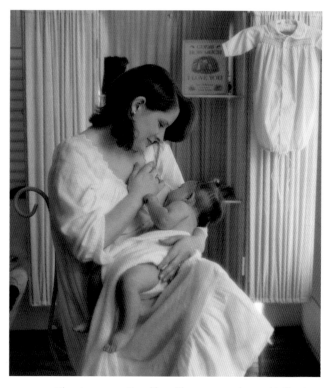

The strong emotional bond between mother and infant is clearly communicated in this soft nursing portrait.

A baby's bare fingers and toes are sometimes the best costume of all.

To keep an infant sitting securely upright, run a ribbon
inside her dress and tie it to the back of the chair.

When you can't get a smile, take what you can get.

Sometimes a baby's thoughtful expression makes an even better picture than a big smile.

said, there is no better setting for a newborn child or infant than when nestled in a parent's loving arms. Often the hardest trick is to convince Mom, in particular, that you really want her in the picture. Mothers of newborn children almost universally agree, "I've looked better." Convince Mom that she is simply a prop in the photograph; she doesn't even have to look at the camera . . . just look down and smile into her baby's beautiful eyes. The two can be looking at a rattle from Grandpa, a favorite picture book, or just holding each other tight looking out the window. Another cute idea is to take some action-packed pictures of the baby all covered in suds while Mom or Dad props him up in a little bathtub or basin. This, by the way, is one photograph you cannot do by yourself, no matter how refined your juggling skills.

An intimate image of the bond between mother and child is a softly illuminated photograph of the baby nursing. Just place mother and child in soft window light (make sure the mother is covered up enough to protect her modesty), and let them be together as one. They both should be looking not at the camera but at each other. This image will be a priceless memory for the rest of their lives.

Once you have captured the maternal bond, take some pictures of baby alone. You might start with him lying in a stroller or on a bed next to a window; just remember to keep the baby's face directed toward the incoming light. Don't try to induce a big smile each time you press the shutter button; try to record some softer and more thoughtful expressions too. Years from now, you're going to want to remember the full repertoire of your baby's expressions.

Up until about three months, most babies are unable to lift themselves up onto their hands or elbows for very long, if at all. However, with a little assistance, you can create the illusion that the baby is lifting herself up to look into the lens. Simply prop the baby up on the edge of a chair or sofa, at about a forty-five-degree angle. A well-placed pil-

When posing a baby with an older sibling, give the two of them something to share—a book, a toy, or maybe even a flower with a tiny candy hidden in it to keep the baby's attention.

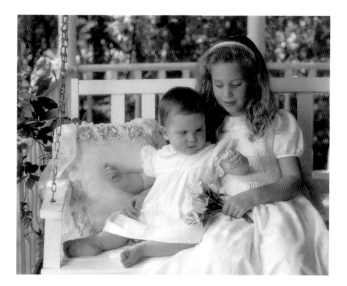

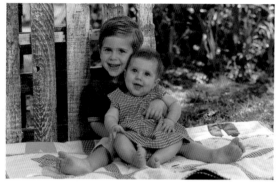

Plan ahead and be ready to act quickly when making toddler-infant portraits. One or the other of them will likely get bored before you have a chance to take more than a few pictures.

low or two can help the baby stay in position and feel comfortable. Place the camera at the baby's eye level and make sure her hands are positioned to support the weight of her head. She won't be able to hold this position long before tiring, so have your camera ready to go before you place her on the set. Also, have someone nearby to help adjust the baby's position, hands, and clothing and to make sure she doesn't fall off the chair—at this age they tend to slide around a lot. This is a wonderful eye-to-eye moment with the baby, and it creates the effect that she is getting up to start exploring her new world. Pulling a blanket up over her head to peek out from is a great way to frame the baby inside the overall frame of the photo.

Posing a baby wedged into the corner of a piece of furniture usually looks just like you have wedged the baby into the corner of a piece of furniture. The baby generally looks uncomfortable and unstable because, in fact, he is. This is not a bad way to get a pleasing head and shoulder pose, if you can be quick about it, but it is at the bottom of our list of preferred poses, and before too long the baby is going to hate it as well.

Posing the baby alongside his toddler-age sibling is one of the greatest challenges in all of children's photography. The toddler is too little to support the infant comfortably and securely, and often by the time you get the pose looking natural and comfy, the toddler spots a toy across the room and nonchalantly drops the baby as he goes off to get it. (Some toddlers are, of course, far more patient and helpful with their baby siblings than others.) In addition, the silly little things we do to entice cute expressions from toddlers are very different and much more aggressive than the ways we try to elicit a baby's smile. So, while you have one laughing, the other is getting bored and cranky. Nonetheless, this photograph is well worth your best efforts, but think beforehand and have a plan of attack before just handing the baby over to two-year-old Max and hoping he is in the mood to cooperate.

Excellence Is in the Details

As mentioned earlier in this chapter, a soft light is preferred for photographing babies. The easiest and least expensive way to get this quality is to use window light or perhaps the natural light on a porch. All you really need to think about is keeping the infant's face directed toward the window or other primary light source; you also have to remember to turn off your flash, which otherwise is apt to overpower the softer natural light. If Mom is

in the photo, make sure her body does not block the pretty light from reaching the baby's face. Remember, Mom is serving as a prop unless both are looking into the camera, in which case you should make sure that both faces are nicely illuminated. (Hint: new mothers tend to hate the way their arms look, so steer them into wearing clothing with long sleeves, which also makes a natural frame for the baby.) These portraits are excellent opportunities to use soft-focus filters, individually and in combination. This is particularly true when the baby is not looking into the camera.

Remember that one of the main characteristics that makes a baby a baby is that they are very little. Make sure to move in close enough to record their delicate features. Too many baby pictures are taken from five or six feet away and include all sorts of wasted space, when the essence of the photograph should be the baby. Don't be afraid of coming in just a couple of feet away for a close-up head-and-shoulders portrait now and then. (But make sure not to come in closer than the minimum focusing distance for your particular camera.) If you use a camera other than an SLR that does not allow you to look through the actual lens as you compose your

You can have Mom either look up at you or down at her baby; just make sure she doesn't look down so far that you see only the top of her head. Meanwhile, you need to be entertaining the baby and holding his attention. If Mom is looking up, make sure she's looking at you and not at your camera, so that she and the baby are both focusing at the same point.

picture, you may suffer a problem known as *parallax error* when creating a close-up. With a point-and-shoot, this could cause you to accidentally crop out the baby's scalp or toes since what you are seeing in your viewfinder is an inch or so off axis from the actual lens view. Check your owner's manual for ways to avoid this problem.

If you plan to photograph infants on a regular basis, put together a collection of "smile getters" (see page 95). These may include bells, whistles, squeaky things, and brightly colored fuzzy toys to hold their attention. But be careful not to inadvertently scare the baby! If you like the look of portraits with the baby gazing out a window, get a small stick from the craft store and attach some jingly, colorful gizmo on the end, then hold it out in the direction you want the child to look. This keeps you next to the camera, ready to capture the image. Getting smiles from most infants until they reach about three months of age is a real hit-or-miss proposition, so don't take it personally if you have no luck getting two-month-old Katherine to smile. Just take whatever the baby is of a mind to give you and be satisfied knowing that you have captured on film as real an emotion as you can.

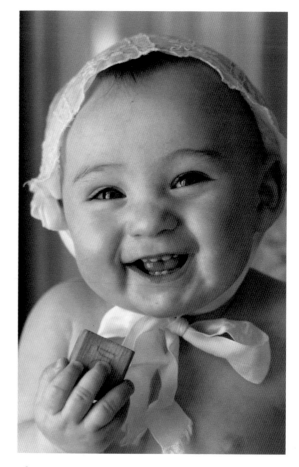

After you have created a wonderful setting full of meaningful props and perfect color harmony, don't forget to come in for a few great close-ups. Bonnets make a cute frame for the baby's face.

Ten Smile Getters

1. When photographing babies and small children, you can get a wonderful smile by playing peek-a-boo behind your camera or a plaything. If your camera is mounted on a tripod, and you're connected to it by a cord that gives you some freedom of movement, you'll get better expressions because the child will be able to make eye contact with you instead of your camera.

2. You can get cute expressions by tickling a baby with a feather duster. Start at the toes and work your way up, being careful not to get too close to the baby's face. (Sometimes babies get scared or irritated if they feel that you are poking them in the face.)

3. Because children usually have short attention spans, you can distract them or change their moods with something as simple as fanning them with a piece of cardboard. The sudden swish of air catches them off-guard and will almost always be rewarded by a beautiful, natural smile.

4. Puppets get great responses from small children, especially if you make the puppet peek out from something or ask the children questions.

5. My favorite way to get a natural expression is to play an animal sounds game. I tell the child the animal, and he has to tell me the sound the animal makes. You will notice a beautiful light in the child's eyes when you tell him the animal and he realizes that he knows which sound to make.

6. A quick way to get a child's attention is to fake a very exaggerated sneeze.

7. Squeaky toys work really well to get a response from a child. Brightly colored ones work best.

8. Hide Cheerios or small bits of cookie in a flower or a book to get children to cooperate and to focus their attention.

9. I keep a small vial of bubbles in my camera bag. Blowing bubbles is an instant way to get a child to perk up and flash a wonderful expression. But beware: the child may get very upset when the bubbles end!

10. If none of the above suggestions work, you can always resort to bribery! We have a wonderful old trunk filled with "treasures" from the dollar store that we use to bribe children, and we've also have been known to promise them a sucker or cookie in return for a big smile.

8. Chasing the Elusive Toddler

What distinguishes a toddler from an infant is the fact that they do, indeed, toddle around. Once they start crawling around on the carpet, children become moving targets for the camera, and this is inevitably part of the process, and part of the fun, of photographing them. This fact of life dictates much of what we do when attempting to take great pictures of them.

Perhaps the most important key to taking consistently successful pictures of toddlers is working around their schedules. No matter how experienced and talented, a photographer is seldom a

match for a tired, fussy toddler. Of course, some remarkable pictures can be made of a baby in full cranky mode, but you won't get much variety from this kind of a session. Still, these screaming-fit pictures might be fun to pull out at the child's wedding-rehearsal dinner a few decades later!

Six to Twelve Months

At about six to eight months, children usually develop the ability to sit up unassisted. This may be the easiest age to create wonderful baby pictures. The baby is no longer a fragile little infant but not quite a big kid yet. Thus, he can sit up and be very amused at all the funny little things you do and noises you make but not yet be able to run away or challenge your control. Best of all, he hasn't learned how to use the word no yet.

Since so much of early infancy is associated with the bond between mother and child, you might consider these later months a great period to start illustrating the love of father and child. The different things they enjoy doing together, such as looking at picture books or playing "Superbaby" up in the air, offer wonderful picture opportunities, as does the simple act of Daddy's rocking the baby to sleep.

Think of personal items you might have stashed away that could help tell a wonderful story about the two of them. Perhaps tucked away in a closet is a teddy bear or a first baseball glove that belonged to Dad as a baby. Maybe Dad's mother has stored one of his baby blankets or a book she used to read to him that you could use today in a picture. Dad could even read this book to the baby with his own mother posed just behind his shoulder, looking down at her son and grandchild. Think how special that photograph would be in the years to come. Again, a little bit of thought and

Make sure that Dad as well as Mom plays a big part in childhood pictures.

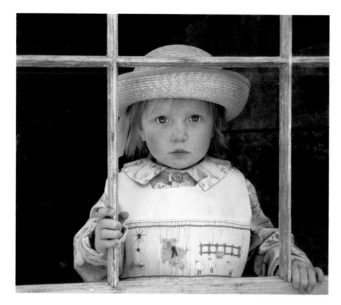

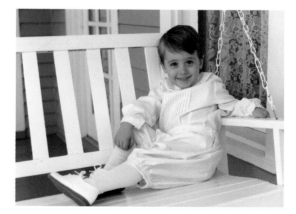

Kids at this age are old enough to express a full range of moods, and you can't always pick the one you want on any given day.

creativity can yield an image that is much, much more meaningful than a technically perfect photograph lacking personal content.

One to Two Years

Then one day, the baby takes her first step. Along with moving everything breakable in the house, you will need to become more mobile with the camera. Being completely prepared before placing the child in the desired setting is even more important now, for she may not share your enthusiasm for staying put for very long. This is also when you will start having to pay more attention to your shutter speed, making sure that you are using a fast enough speed to freeze the movement of all

those arms and legs. Usually 1/6oth of a second is a good minimum speed, with 1/125th or faster even more foolproof.

One year of age is about the last time you can take photographs of this little person in pretty baby clothes and bonnets still looking like a baby rather than a little boy or a little girl. You can still take great baby pictures, but you can also start to portray children at this age in more grown-up terms. They can react to their environment now, so give them a flower to smell, a pet to cuddle, a lollipop to smear all over. Want to make it even more of a storytelling scene? Sit them beside an antique ice-cream maker or surround them with pasta, whole tomatoes, a bottle of olive oil, and a big pasta pot (with a helper close at hand to keep the action safely under control). Be creative and make up a story. Then capture their emerging personalities as they react to the props.

It is a lot easier to photograph a one-year-old before she starts walking or running. By posing her with something to hold onto, you give her stability and create a more interesting composition. To add variety to your portraits, try photographing close up with the camera tilted at a slight angle; this will add a suggestion of movement and keep the picture from looking static. Because a toddler's attention span is so short, plan on a variety of props and backgrounds so you can make a quick change when the child gets bored or tired.

Though this image could certainly be improved, when you see cute expressions and nice lighting, take a couple of quick exposures—don't wait for perfection.

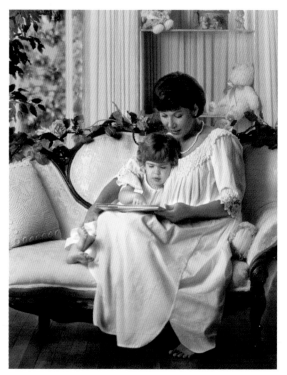

This mother-daughter image includes several personal items that this little girl may someday share with her own children.

So, you've managed to find or create a beautiful setting with perfect light, seemingly heaven-sent for making wonderful pictures. The child has just had a restful nap and a tasty (but not messy) snack. He lets you position him at the perfect point in your composition, and you go back to your camera. You turn to focus on the child and suddenly you realize . . . there no longer is a child in your viewfinder. A moment later you discover him drinking from the bird bath, with his perfect little outfit totally ruined. You think back fondly to the old days, when you could just plop him in the stroller and take his picture all day long. Welcome to the real world of children's photography!

Fortunately, we have options. (We are not referring to duct tape.) First, give the toddler something entertaining enough to hold his attention until you can focus your camera and take the picture. Capture him interacting with the prop, whatever it may be, as well as when he looks up and gives you that heart-melting smile. You might get really lucky and capture three or four wonderful expressions in sequential images that can be hung side by side or even matted together in one frame. We call these arrangements *storyboards*.

It is advisable to have someone stationed close by to help keep the child in one place. Just make sure this assistant knows to be quiet if you are trying to have the child look your way and remind her that any distractions she creates will make your task much more difficult. If you can, place your helper in a position beside the child so that if the child looks up at her, he is, at least, looking in the direction that works best with the existing lighting. Make sure the helper is also placed where she won't block your natural light or flash.

Now, suppose that you're determined to take some photos but the child is screaming and squirming and just refuses to stay in one place for more than a second. Plan A would be to give up, take your camera, and go photograph a beautiful sunset. Plan B might be to follow the child around the house or yard and wait patiently to see where he wants to go—or, more accurately, where he decides to stop. He might pick a terrible place with difficult lighting and distractions on every side. Or he might do something wonderful that only that

The First Birthday

A great portrait taken as close as possible to a first birthday is one of the most important pictures you can make for a child, and every effort should be made to create something special. The classic approach is to create a birthday party setting featuring a cake with candle, cookies, party hats and favors, balloons, and the works. Make an effort to establish a pleasing color harmony with all the decorations and clothing. Set the shot up in the kitchen, on the porch, in the park, or wherever it makes sense to celebrate this milestone. If you opt to light the candle, have a friend very close by on safety patrol for when the baby tries to grab the flame.

When photographing something as special as a child's first birthday, place a few meaningful props behind the child. Keep them at a distance of four to five feet away from the camera so that they will be recognizable but not sharp enough to distract attention away from the birthday girl.

child might think of doing, giving you a photograph that you would never have thought to set up. Your friends will say things like, "Oh, you're so creative. How do you ever think of all these cute ideas?" And you can just smile modestly and tell them about this wonderful book!

Of course, if the child simply refuses to cooperate and be cute for you, there is always Plan C: take the picture anyway. Misbehaving can produce a really telling portrait of a child—perhaps it won't seem so cute while you are taking it, but someday you'll be glad to have it. Again, we advise you to capture all sorts of moods and emotions. Don't miss something unforgettable while trying to capture something unattainable.

Children at this age are easy to excite. They are becoming very curious about things, and they are full of energy just waiting to be captured. Take advantage of these characteristics and do whatever you can think of to capture their emerging personalities. Two-year-olds have a reputation for obstinacy for a reason; they have learned the word no and they are not afraid to use it. The most impor-

tant thing is to avoid playing a game of control with them. You will lose. In fact, the contest will not even be close. Think in terms of positive reinforcement rather than trying to force them into something they would rather not do. Again, give them something entertaining to do and capture them in their joy. Some photographers offer "bribes" (candy, a Happy Meal, a new toy) if the child will just sit still and pose. Some people think this is a bad idea. Others feel it depends on how much time, money, and effort they have spent setting up the shot!

Know your child's moods and expressions throughout the day. Think in advance about what toys, trinkets, and activities elicit predictable and useful reactions. Use this ammunition to set up and prepare for your pictures. Be ever ready, with your camera poised to fire whenever that perfect moment comes along during a photo session. And when things are going right, don't stop with the first picture—take a series and create a little portfolio of memorable expressions and gestures.

9. And They're Off and Running

Toddlers grow up to be "little people" before you know it, and a whole new world of photographic challenges and opportunities now awaits you. One characteristic you discover is that as children grow up they become even faster on their feet and they develop more . . . let's call it self-will. You will find it increasingly difficult to make them sit and do any one thing long enough for you to create your masterpieces. It now becomes all the more important for you to be completely prepared in terms of your camera, film, lights, and so on, before you ever place the child in the setting you plan to photograph.

Little Kids

These are the fun ages, from about one to five or six years old. Children this age often develop a special closeness to a particular blanket or toy and can be made quite comfortable in any setting as long as their "buddy" is with them. If you're lucky, it won't be a bright, flashy, colorful object that will dominate their pictures. Sometimes, the buddy they desperately want to hold tight is Mommy. This can make it particularly difficult to photograph the child if the Mommy is you. Clingy children present a challenge for amateur and professional photographers alike. Don't become discouraged too quickly if you cannot pry the two apart. If the mother is not the photographer, let her stay close to the child. Use a longer lens, if possible, to help keep Mom out of the frame and let you work from a greater distance, so that the child feels more secure in his own space. Then help Mom gently coax the child into the position you want before easing away at the last moment. Patience and the desire to get a great picture are the keys to overcoming clinginess.

One way to get a child excited about a photo session is by including her puppy, kitten, or other pet. Why do you think social workers use furry little animals in children's hospital wards to lift the patients' spirits? Because it works. The pet can simply sit beside the child or in her lap and smile right along with her; or, it can be part of the action—playing with a ball, for instance. Maybe the child can be brushing it or, for a really fun picture, giving it a bath. The more suds all over the place, the better!

Kids at this age always seem to be doing something different, and nothing is more exciting than photographing a defining moment in their childhood. A perfect example is the collection of still and video pictures of three-year-old Tiger Woods

A long lens was used from across the room to allow Mom and daughter a moment "alone" to think about the new addition to their family.

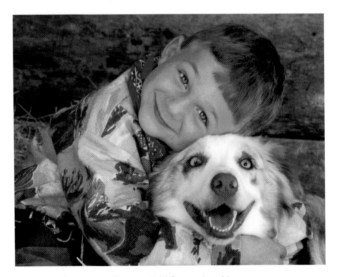

Playing with a pet can keep a child focused and happy during a photo session.

taken by his father as he was swinging a golf club. How wonderful those photographs must be for both him and his family. A friend of ours was photographed posed beside his dad's professional

camera when he was just a few years old. Now he too is a fine professional photographer, and that old picture has become a family treasure.

You will likely want to take some formally posed portraits of young children, for they will probably record the child's features most clearly. Just plan ahead as to where the child will sit or stand and be very patient as you create these photographs. Remember that formal poses are far more interesting to the parents and grandparents than they are to little Dustin, and you may have to coax or bribe him to achieve the perfect pose and

Have your camera, lighting, props, and everything else ready to go before positioning the child for a formal portrait. Children aren't as likely to wait around for you in a formal setting as they are when playing with their puppy.

expression. A formal portrait is also the time to pay more attention to the sort of detail that is not so important in casual pictures. You will want to concentrate much more on checking for collars out of place, dresses hanging straight, wrinkles smoothed out, and so on. You might find it helpful to have a friend watch for these details and keep the child in one place while you concentrate on expressions and poses.

We have found it is often easier to photograph other people's children than our own. To a client's small child, we are new, funny, and interesting. But our kids already know us and all of our little tricks to elicit their smiles, and they've already mastered their own repertoire of things they can do to try to gain control over us and the photo session.

Appealing portraits can be made by placing the child amid his parents' or grandparents' things. For example, set up six-year-old Josh with Daddy's fishing stuff and have him sit next to the pond. Or pose five-year-old Susanna in Grandma's attic surrounded by a collection of her old dresses and hats. These theme pictures—using personal possessions that cannot, we hope, be destroyed by a small child—could be related to a parent's career, hobby, or collection. Consider all the possibilities if Mom or Dad is a firefighter, a tennis player, a model maker, a collector of sports memorabilia, or even a lawyer.

For more informal shots, you can allow young children to get really messy and then take some photos of them painting something, rolling around in a mud puddle, or making a complete mess with their food. Dress them in overalls with no shoes or shirt and lean them against a tree with a big messy bowl of chocolate ice cream. Just make sure they understand when the photo shoot is over and it's time to clean up!

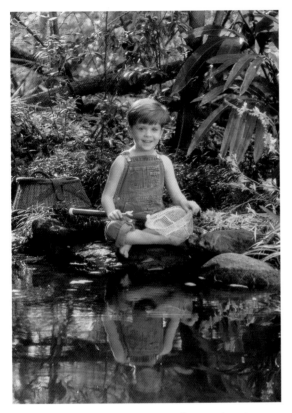

For little boys there is no more appealing combination than a fish pond, comfy overalls, and a summer day. Waiting until late afternoon will give you lovely golden backlight.

"Dress Up" is not just for young ladies. This handsome gentleman is all duded up in Dad's clothes.

Big Kids

At some point, around seven years of age, young children seem to turn into big kids. They start developing their own personal style with respect to clothing, music, entertainment, and favorite pastimes. In effect, they are opening the doors for you to observe them and to discover creative ways to capture their emerging sense of self in a portrait. They are now very much at an age to become a willing participant in the process.

Many ideas for children seven and older will be similar to those we have talked about from early childhood, such as photographs with pets. But kids at this age now do things they couldn't do be-fore. They ride bikes and skateboards. They play the piano. They read and write and play computer games. They participate in sports, scouting, and other organized activities. All of these and many more offer wonderful opportunities to take personalized portraits that the child will enjoy reliving years from now. Remember, you are capturing a permanent record of this stage in their childhood.

Most important, just as when the children were younger, search for ways to make the photo

Some poses and ages are perfectly suited to a dose of attitude.

These two brothers seem so intent on their game that they've completely forgotten about the camera.

Environmental photographs that include interesting natural elements work well for older kids because they don't feel as though they are being forced to sit, pose, and smile on command.

Take the time to find ways of making the photo experience enjoyable for your children. If you set up fun situations for them, they will tend to get absorbed in their play and you'll be able to capture their true essence on film.

Think of children's photographs as a wonderful gift to them twenty years from now, a gift that will take them back to the dreamy days of childhood.

experience enjoyable and encourage the children's active participation. Involve their friends and relatives and create great group photographs of their sharing a secret, a hammock, a park bench, or a bicycle built for two—or perhaps playing dress-up or having a great big pillow fight. Don't forget that some of your all-time favorite pictures will be the ones least expected.

Children have so many stories to tell. With your camera and a little experience, you can record some of childhood's most vivid memories. How lucky that you will able to record these memories, and how fortunate they are to have you doing it for them.

10. Your Own Sense of Style

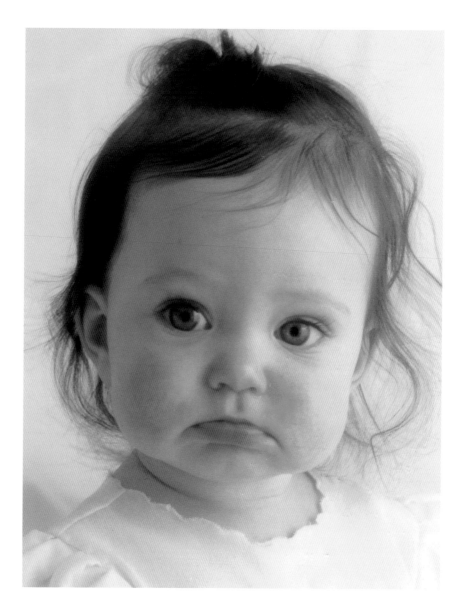

Your own personal style is what will differentiate your photographs from the next person's pictures of the same children. If you hired any two professional photographers and placed them in the same park on the same day with the same children and the same equipment, you would see two totally different sets of pictures from each of them at the end of the day.

In the beginning, you'll tend to concentrate on the more technical aspects of taking a picture. Once that all becomes second nature, give yourself permission to let your emotions and personal

aesthetic pervade your pictures. This is your invitation to go out and create something new and original. Expose yourself to fine art and photography. We have found great inspiration by studying the works of artists ranging from Thomas Gainsborough, Edgar Degas, and John Singer Sargent to Norman Rockwell. Allow yourself to be influenced and inspired.

We will try in this chapter to give you a sense of the diversity you can achieve in children's photography. Some photographers favor a soft pictorial or environmental style, while others excel in tight, sharply focused compositions. Some are most at home creating very formal or classical portraits. Others leave traditional lighting and posing to others, getting excited instead about photojournalistic images in which the children are totally unaware of the camera.

We will show you examples of various styles, and we encourage you to experiment with several different approaches, even if they don't feel right to you in the beginning. Such diversity will have a positive influence on all of your photography down the road, and it might help you uncover a whole new route to your own personal expression.

Pictorial and Environmental Images

Pictorial or environmental images are like those you might associate with an Impressionist painting by Claude Monet. Yes, Monet often created masterpieces that included people, but the people were no more or less important than the flowers, the water, or the trees. In modern-day photography, children can be treated in much the same way when they are allowed simply to be at one with their surroundings. This could include a child building a sand castle on a pristine beach or riding the merry-go-round in Central Park. In environmental photographs, you, the artist, plot the story

you want to tell about a child or group of children and then select the right environment to communicate that story to the viewer. It is your story to tell, and only you can determine how it is told and whether or not you achieved your goal.

Of course, the overwhelming majority of children's images are positive and uplifting. When taking an environmental image of children, the easiest starting point is to think of where they are the happiest. It may be at the pool, the park, or with a pet. You might think that a child's favorite place is not photogenic enough to merit the time and trouble to photograph it. We encourage you to think again. There must be a reason the child feels happy and comfortable there, so see if you can figure out a way to make the location work in a picture. Is there an unusual camera angle, a certain

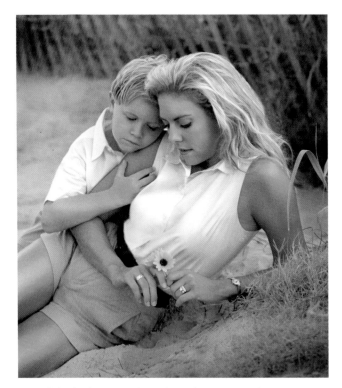

Note the color harmony throughout this image, right down to the flower.

Above: This environmental image was the only shot on the roll in which we didn't get a great smile, and it was everyone's favorite.

Right: In this classically posed portrait, reminiscent of Thomas Gainsborough's painting *Blue Boy*, the boy's weight is shifted forward to his front leg, with his shoulders and head squared.

Below: Mom and Dad carted all of these props down to the beach, along with their kids and collie. It made an appealing environmental portrait, even though the dog refused to smile.

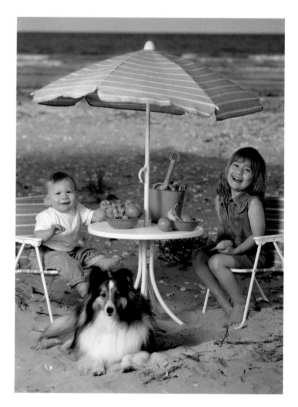

lens, a time of day, or some other element within your control that helps your environmental picture work aesthetically while at the same time telling a story? Taking an unpromising scene and making a good image from it is a great training exercise.

After settling on your location, think of props and other storytelling items you can use. Some might be placed in key spots around your picture, and some might be important enough for the child to interact with while you take the pictures. Involve the children in the planning process, if they are old enough, and elicit from them the important things in their life that they cherish and want to include in their picture.

Now that you have the location and the props, you know what the key colors are in the scene and can select the right clothes to enhance the photo's color harmony. Generally, you should select clothes that either blend in with the main elements of the scene or completely stand out from

Close-up portraits intensify whatever expression the child is giving you. Occasionally we will get such an irresistible expression that we will crop out all of our well-planned props and settings right down to that wonderful face.

it, such as a child in a bright red outfit placed in a field of yellow sunflowers.

Once you have all of the ingredients for your picture, simply place the child wherever you want him to be in your composition, step back, and let him be a child. You can help by suggesting different things for the child to do—blow bubbles, pick flowers, water a plant . . . but allow him to do it in his own particular way.

Close-ups

Many photographers love portraits characterized by tight close-up pictures of children looking straight into the camera and featuring very few, if any, props or other storytelling elements. The tight cropping brings you right into the child's face and can be riveting when done well. Because the entire story must be told in the child's expression alone, this style of photography requires a keen intuition and great timing. It's a style of portrait that, when done well, can reveal a child's heart and soul. The lighting can be flat or dramatic, the posing and

clothing can vary immensely, but either you will capture that magic moment of expression or you won't.

One key to this style of photography is, again, helping kids find a way to relax and be themselves. Capturing that moment when a small nuance of expression reveals a character trait is your goal. Most people find it far more difficult to achieve this in the "in your face" style of photography than in a more relaxed pictorial style. The camera is just a few feet from the child, which forces him to stare right back into it, without any prop or puppy to relax with. When this sort of photography is successful, it usually is due to the engaging personality and comforting style of the individual photographer. The difference between a stark mug shot and a close-up portrait that offers a glimpse into a child's soul is difficult to achieve but well worth attempting. Be prepared to shoot a lot of film, as you never know when that little glimpse into a heart will be revealed.

When the light source comes from the side of the child, it is called "split lighting."

If you want to photograph a side view, turn the child's face toward the light until the light rims her profile. This rim lighting also works well for bringing out beautiful detail in clothing.

Classical Portraiture

Classical portraiture is what most people associate with going to a portrait studio. With children, you dress them in a nice Sunday dress or a cute little suit, and the photographer places them in a stiff formal chair under standardized lighting designed to work with almost any face.

One normally thinks of a basic set of guidelines distinguishing classical portraits from other more contemporary styles, but they do not have to be this limited. The child can be dressed in clothing ranging from very formal to loosely casual. The setting can be a studio, a living room, or outside in a garden. The child can be posed seated, standing, or lying down. Though we are not trying

to train you to go out next week and open your own studio, we will give you a set of basic posing and lighting rules for classical portraiture. This may not make terribly exciting reading, but the following rules are the foundation of what we do every day in our own studios.

In general, artists have classified three basic views of the human face: the full face, the three quarter view, and the profile. When taken correctly, these views allow you to photograph the face without any unattractive distortion. See the illustrations on these pages for a quick lesson on facial posing.

Classical portraits tend to rely on different conventions for photographing men and women.

Men and boys tend to be photographed leaning into the camera and with the head tilted toward the lower shoulder. Women and girls are more often posed with the weight back and the head tilted toward the higher shoulder. As stated many times in this book, such rules can be broken whenever there's a good reason to do so. One way to start learning how body language can be put to effective use in a portrait is to practice by looking at yourself in different poses in the mirror, leaning your body and head this way and that. (This is probably best done without an audience!)

Classical lighting is usually thought of in terms of three basic types. One is direct, or *flat*, lighting—when the light strikes the face straight on from the camera. This is what you get with the built-in flash on a camera, which produces a flat, evenly lit portrait with no shadows. The drawback is that the face becomes very two-dimensional. The most popular lighting is with the light source set at about a forty-five-degree angle to the subject and the face turned either toward the lighting or directly toward the lens. Generally the most flattering lighting for portraiture, this creates nice highlights just where you want them, while leaving the opposite side of the face in shadow, all of which contributes to a believable three-dimensional representation. And finally, when the light is moved to either side of the face, the result is known as *split lighting*. This can be very dramatic, leaving one entire side of the face in shadow, but it usually is too severe for a child's portrait. Done delicately, it can be a slimming light for a subject with a very round face, but it is by far the most difficult lighting method to use well.

When we want to take a profile of a child, we often move the light source around to the child's side to light up the front, or the mask, of her face. When the light cannot move, as in the case of a

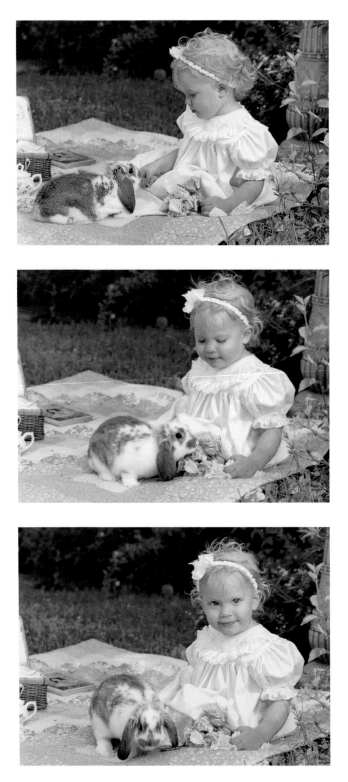

In this sequence you can see a profile, a three-quarter, and a full-face portrait, each with its own charm. When posing a child on the lawn, it's a good idea to keep a blanket handy for her to sit on—that grass can be very prickly.

Hand-tinted black-and-white storytelling images create a nostalgic effect.

window, you can move the child toward the camera, causing the light to move to her side, as shown in the examples on pages 67 and 75.

Classical posing and lighting information could consume several chapters in this book, so we must keep it relatively abbreviated here. But as you move along your own creative path we encourage you to learn more about all the classical views of the human body and lighting patterns used by artists.

Fantasy Portraits

We've saved our favorite for last. When you think about the land of make-believe, what comes to mind first? Children, of course! Fantasy portraits give you an excuse to let your imagination run wild. Once you have honed your skills by taking many of the other types of pictures we have been discussing, invest a little time and effort in creating a fantasy photograph of a child.

Maybe you could create a Little Red Riding

It is worth taking the time and effort to create a fantasy portrait of your child. With enough imagination, the possibilities are endless!

An old-time soda fountain and a cute outfit made by Mom add up to a fun fantasy portrait.

Hood portrait. Make or buy a simple red cape with a hood, put together a little basket of goodies for Grandma, and set off with your little girl for a wooded path in a nearby park. For extra storytelling effect, dress up her little brother in a "Big Bad Wolf" costume.

Do you know a little boy who likes fire trucks? Find him a bright yellow raincoat and big rubber boots. Get him a fireman's hat and take him down to the local fire station or even just to a downtown fire hydrant. Perhaps a friend has a Dalmatian that could sit beside him. Take a set of cute pictures with the boy all cleaned up. Then, get him all dirty and smoky looking, and mist him down with a squirt bottle to look as though he has been fighting a high-rise fire for hours. Then let him sit down by a puddle, looking at his fireman's hat or holding on to the Dalmatian, and have him pretend he's completely worn out.

By now you probably get the idea. In a fantasy photograph, children can be anything adults can be. They can be doctors, sports heroes, farmers, cowboys, architects, ballerinas, a rock 'n' roller from the '50s . . . the list goes on forever. The photo doesn't have to be set in a suburban garden or rural field. Depending on the fantasy, it could just as easily (and sometimes, preferably) take place on a downtown street, on a dock, at a Ferrari dealership, in an airport, or at a sports stadium.

A fantasy portrait goes beyond just putting the child in a cute outfit and taking a snapshot on the porch. Decide with him in advance what would be fun to do together, and then do it until it is right, taking time to finesse the details. You'll need to find the perfect, believable outfit. Some parents enjoy making costumes, but you can also go to the local theatrical supply house that outfits the neigh-

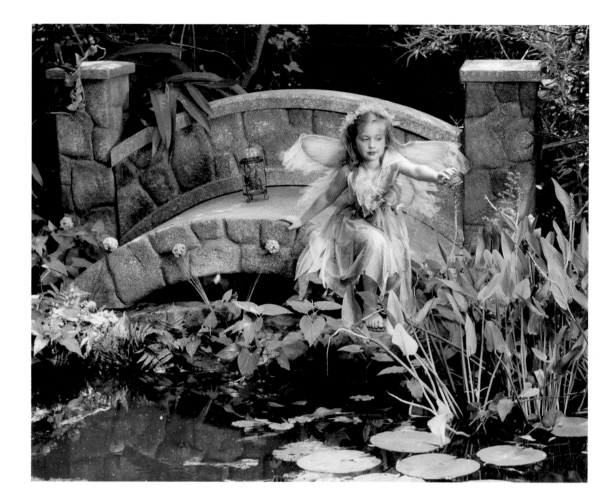

borhood schools for their plays and see what costumes and props they might have to rent. (And ask if they will trade with you for a great sample picture featuring their rental stuff—it's worth a try!)

Before you start photographing, think about the details. If little Wesley were a real cowboy, what stuff would he have with him? What activity would he be involved in? What would be the look on his face?

We create fantasy in our studio work all the time. It is a big part of what helps us to stay alive, creatively. We have made inexpensive yet believable costumes for fairies, angels, Robin Hood, princes and princesses, cowboys and Indians, and much more. We have collected props from antique stores or craft shows and found great stuff just lying on the side of the road. Over time, we have

trained ourselves always to be on the lookout for anything that might somehow become part of a child's fantasy world. This process has become our passion, and we hope it will become yours as well.

Once you have put some effort into creating this magical setting and outfit for your child, talk to his friends' parents about doing something similar for their children. Not only is it a thrill to create something like that for someone else, but you might even be able to charge them a few bucks for the opportunity. Then you can go out and buy that cool new lens you just have to have!

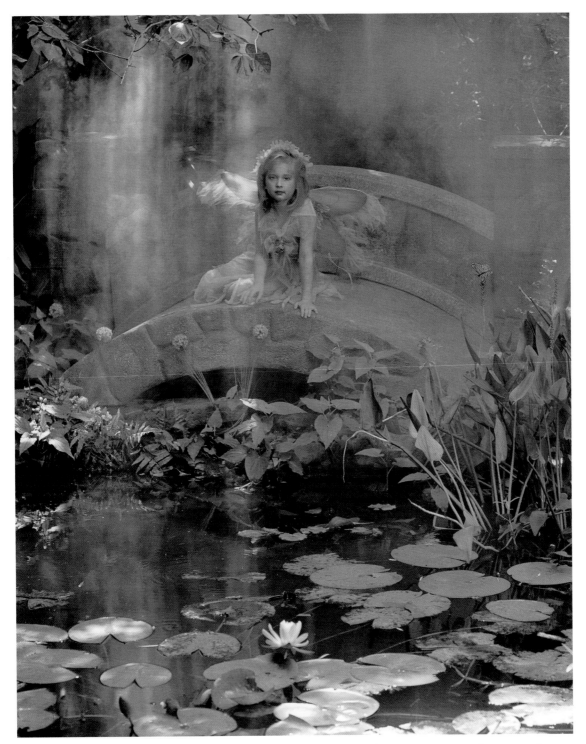

Opposite: You can transform an imaginative child into an enchanting fairy by gluing strips of sheer fabric and silk flowers to an old dance costume or leotard. The wings can be made by spraying store-bought wings with translucent paints and stretching colored net across them. Twine additional flowers into a halo to complete the costume.

Above: Add magic to fantasy portraits by using smoke to create an otherworldly ambiance. We use a propane mosquito fogger, filled with liquid smoke from a theatrical-supply company. Shooting in the late afternoon will be rewarded by beautiful rays of sun beaming through the mist.

11. A Race to the Finish

Now that you have been inspired to take some wonderful new pictures, you have to turn them over to a photofinisher. Just what is a photofinisher, this technician you'll have to trust with your most precious memories? Most often he is a part-time employee operating an automated printing/processing machine; too often, he will have no idea what the term color balance means. You often discover this when you are out in the parking lot, tearing into the photo envelope to see the fruits of your work. (If you are reading this book, then you are probably like us—you couldn't

possibly make it all the way home without seeing those pictures!)

Most places that accept your film for processing have staff that are fairly well trained and have a pretty good idea of what they are doing. The automatic processors they run will do a more than adequate job of processing your film (i.e., turning your exposed film into negatives). Once you have a properly developed negative, a good picture is achievable—but quite often it is the printing stage that lets you down. And if the photofinisher fails to capture on photographic paper the image you actually witnessed as you took the picture, it's not necessarily his fault. How could he know what you

Here is what happens when you take one image to four different one-hour labs for printing. The idea is to find a processor who will give you good consistent color prints. Don't accept anything less.

saw? He wasn't there! In fact, color printing is ultimately as much art as science.

If you take four identically exposed rolls of film to four different photofinishers, you will receive in return four different-looking sets of prints. Furthermore, if you take a particular negative back to a photofinisher for a reprint, it will not exactly match the first one that the same store gave you last week. What is different? Perhaps the color balance is bluer or redder. Maybe the picture is brighter or darker.

During printing, your negatives are projected onto photographic paper through a series of filters known as a *filter pack*. This consists of three colored filters that can be varied in different intensities of cyan (greenish blue), magenta, and yellow (CMY). The automatic printers also have a kind of electric eye that senses the density of the negative and governs the amount of exposure time your negative receives on the paper. Changing any of these variables has a noticeable effect on the print.

To complicate it more, different photofinishers use different brands of paper (Kodak, Fuji, Agfa, and so on), each with its own set of color and surface characteristics. Even more confounding is that a machine may be running the same exact paper this week but with a different batch of emulsion than that on last week's paper, causing a slight but occasionally noticeable difference, if the photofinisher is not careful.

So, what can you do to control the process? Find a photofinisher who will listen to you and, with a little luck and perseverance, get to know what you are looking for in your prints. Make certain that the store will reprint your pictures until you are happy with them. Many times, people have shown us their pictures and asked what they did wrong. When we look at their negatives, we can't find any reason the print should have printed too

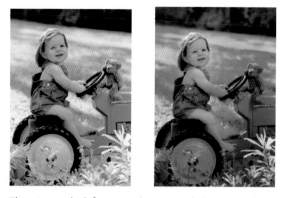

The print on the left was machine printed; the one on the right was custom printed by hand. Notice how the custom printer was able to dodge and burn (lighten and darken) selected parts of the image to reduce distractions and enhance the print.

light or dark or whatever. Nor can we necessarily tell whether a problem is the photographer's fault or the lab's fault. Neither can your photofinisher, so when you question the quality of a print, be sure to make the negative available to him again.

Do not be afraid to ask for a print to be redone. But, to be fair to the photofinisher, there are certainly times when a negative is, for whatever reason, just unprintable. Make it a point to inspect your negatives and get a feel for just how dark (dense) the negative for a great print looks. Some negatives are simply too dark (overexposed) or light (underexposed), and there is not enough information on them to make a quality print. If your photograph is out of focus, you either shot a moving target with too slow a shutter speed, jiggled your camera as you took the picture, or just didn't focus the lens carefully. An out-of-focus negative can never be converted into a sharply focused print (no matter how many James Bond movies you have seen to the contrary).

Select a photofinisher who processes your film and prints your photos right there in the store. Then if you have a question or need a remake, you can talk eye to eye with the technician who is actually going to do the work. Some locations send their customers' film off-site to be processed.

Their rates may be a dollar or so cheaper, but you lose the personal service that is often the difference between obtaining the picture you want and settling for something less.

Perhaps you want to enlarge one of your prints so that it can be beautifully framed and displayed in a prominent location in your home. This might be the time to leave the one-hour-processing world behind and take your precious negative to what is known as a *custom lab*. These full-featured labs can perform many services not available at a mini-lab type operation:

• *Custom printing* The technician hand prints your image and, among other things, can *burn* (darken) and *dodge* (lighten) selected areas of your print, at your direction. This is more often done in black and white than in color. The custom lab can also crop and size your print exactly to your specs. In addition, you typically will be given more than one choice of photographic paper, as well as possibilities for dry mounting and lacquer coating the print.

• *Slide proofing* Your negatives can be converted into 35 mm slides for use in a slide projector.

• Black-and-white printing from color negatives and color printing from color slide film.

• Scanning your negative on high-resolution film scanners so you can post them on the Internet or further manipulate them in your computer.

• *Retouching* Many custom labs have artists on staff who can remove age lines, blemishes, and other skin imperfections right on the negative. If they're good, the retouching will be completely invisible on the final print. (The head size on your negative must be large enough for them to work on.)

Custom labs can do great things not possible at a mini-lab photofinisher. Their primary customers are professional and serious amateur pho-

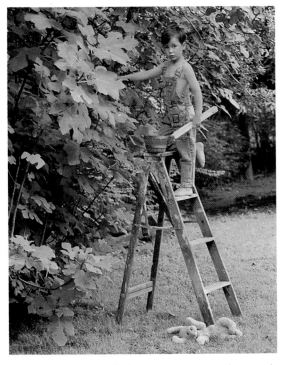

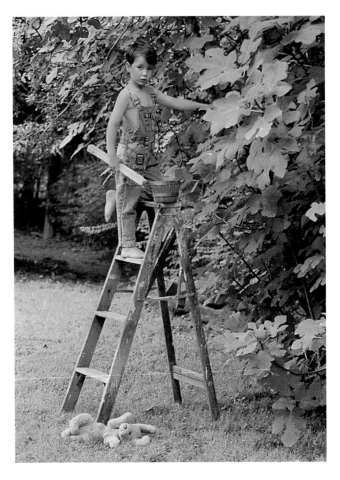

Sometimes you can add a lot more impact to a photograph by having the printer turn the negative over. Notice how much more pleasing to the eye this image becomes when the negative is flipped.

tographers, but most will deal with anyone with a negative to print. Obviously they are going to be more expensive, so if money is an issue, you might want to save them for your most important pictures. And don't expect the custom lab to be able to make a beautiful photograph from a poor negative. It's not fair to the lab, and it usually is a waste of money. Let them use their talents on your best work.

Digital Processing

Once you have taken all of your wonderful new digital images, how are they made into prints? All digital cameras come packaged with the software needed to download your pictures onto a computer's hard drive. At that point, you can prepare them for printing on your inkjet printer, for uploading onto your Web site, or for sending out as e-mail. You might also look for a professional photo lab that will take your images from a floppy or Zip disk and print them directly to photographic paper on one of the new direct digital printers, such as those made by Pegasus and Lambda. These extremely expensive printers make a normal photographic print on traditional Kodak paper and are a very attractive option for digital prints.

The standard today in consumer photo software is PhotoDeluxe from Adobe. Like other similar programs, PhotoDeluxe will help you manipulate your images in a number of ways. You can crop and resize them, adjust the color and contrast, eliminate stray hairs or red eyes, and much more. You can let the software improve your images automatically, or you can go in and use your own creativity.

12. Hand Coloring Your Prints

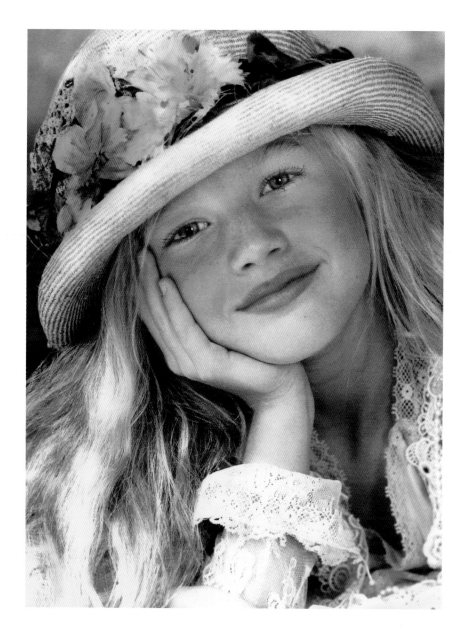

Almost as soon as photography was invented, photographers and artists began figuring out ways to add color to their photographs. With the introduction of color film in 1935, that interest diminished, but today tinted images have a certain nostalgic appeal, and the process of hand coloring black-and-white photographs has become popular again. In the pages that follow, we'll guide you through the process of enhancing your own black-and-white photographs with hand coloring.

Work Area

It is essential that your work surface be perfectly smooth; any bumps or texture could easily be transferred to the print you are coloring. Taping down the corners of your prints with drafting tape will keep them from moving while you are applying color. In your work area you will also need the following: cotton balls and swabs, cotton gloves, erasers, and a magnifying glass or loupe, as well as a clean space where prints can be put to dry.

Papers

The type and texture of paper that your photograph is printed on is very important, because that affects how well the colors adhere to the paper. For photographic paper, the choice is between either a fiber-based or a resin-coated (RC) paper. Matte fiber-based paper has a flat, rough surface that holds oil and colored pencil well, but it takes longer to process than RC paper and it has a tendency to curl after drying. Fiber-based papers give your project an old-fashioned look, but they tend to be comparatively expensive. We recommend that you wait to use these papers until you are fairly skilled and confident in your tinting abilities.

RC paper has a thin plastic coating on the surface and is more readily available than fiber paper; it comes in several different semimatte finishes that have a slight texture: pearl, luster, or satin. Kodak makes an art paper that is available upon request from any black-and-white photo lab. It is less expensive than fiber-based papers and easier to work with than RC papers. You should order more than one print from each negative that you plan to tint, just in case you make a mistake!

For nonphotographic papers and for digital images, we prefer matte or watercolor papers, from Epson, printed on Epson color printers. Epson's heavyweight matte paper works especially well with oil pastels. For hand coloring we prefer matte or semimatte surfaces, since glossy paper has such a smooth, slick surface that oil does not adhere well to it.

Oil Paints

Artists' oil paints can be used, but you will get better results with oils that are made specifically for tinting photographs. Because these are more transparent then conventional artists' oil paints, they allow the photograph underneath to show through. We use oils made by Marshall's, which are the standard in the photographic industry and considered the best oils on the market today. They are a transparent photo oil, with enough pigment to give your print a beautiful, natural look. Available in both two-inch and four-inch tubes, they can be purchased individually or in sets.

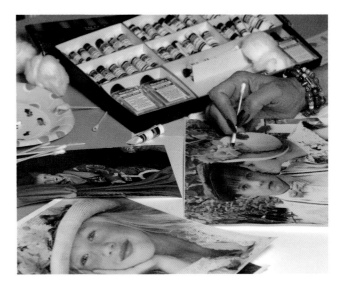

Where Do I Start?

If you purchase a set of Marshall oils, it will include a solvent called Prepared Medium Solution, which should be applied to your print before you start coloring it. If the Medium Solution is not

available, mineral spirits can be used instead. Priming the print before beginning prevents the paint from gripping the print's surface and keeps the paint smooth. Apply the solvent with a cotton ball or a paper towel, using just enough to moisten the area you are about to tint.

Setting Up Your Palette

Since it only takes a little oil to cover a large area, and since paint tubes dry out if left open, we suggest that you squeeze a small amount of oil onto a palette or plate. If the paint and oil have separated in the tube, you can stick a paper clip or toothpick down into the tube and mix them back together. If the paint becomes hard, add a little extender (a colorless neutral base that can be mixed with oils to reduce their color saturation) to soften it.

Applying Color

The most common tools for application of photo oils are cotton balls, cotton swabs, and small skewers with cotton wrapped around the tip. Small brushes are also useful in areas of fine detail.

To tint a face, apply small dots of flesh-toned oil over the whole facial area with a cotton-tipped swab or skewer, then blend the oil evenly over the face in a circular motion, using a cotton ball or facial tissue. To keep the eyes and teeth white, you can clean the color off those areas with an eraser. For the cheeks and lips, apply small dots of cheek oil and then gently blend them into the flesh. Be careful not to apply too much; if the oil is too heavy, you won't be able to blend it to look natural, and it is hard to remove without also removing the flesh tone.

You can add depth to your tinted portrait by layering a single color and by using more than one color of oil; we usually like to work with three. After buffing out and blending the first layer of oil,

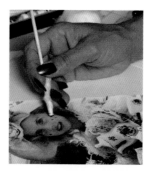

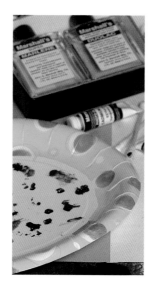

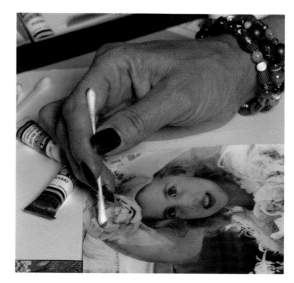

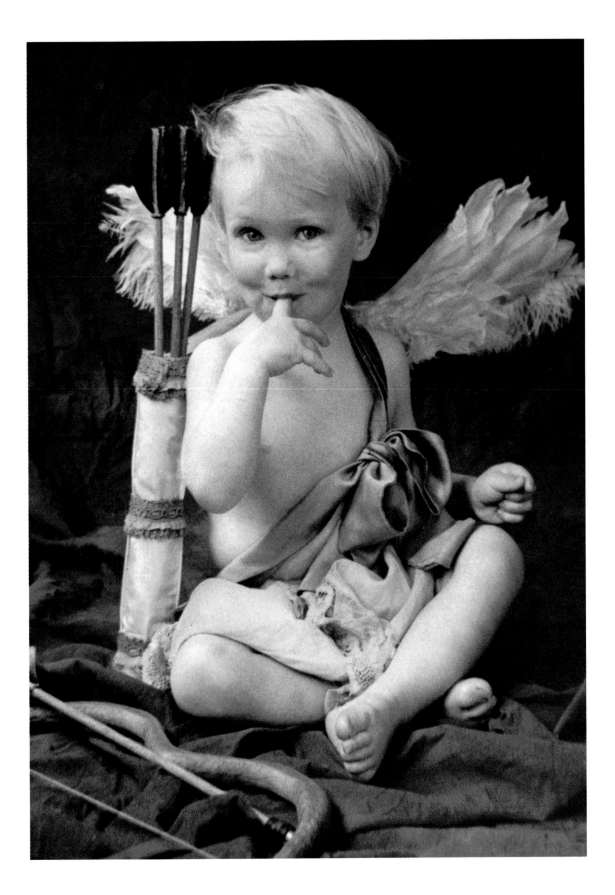

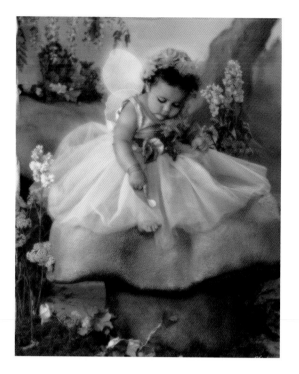

Rub the pastel stick lightly with a cotton swab and then gently rub it onto your print. We find that this technique works better than applying the pastel directly to the print, which tends to make the pastel opaque and then it doesn't blend as smoothly or evenly.

You can use a cotton ball to smooth out the colors if they appear blotchy. If the color is too weak, you can layer colors on top of each other to build up the intensity. In some cases you may want to overlap two colors to produce a more natural blended finish, instead of a harsh edge.

It is important to protect your prints after coloring them with pastels. Before you apply any other sprays, we recommend that you spray your prints with a workable fixative designed for use with pastels. Krylon makes a reasonably priced spray that won't dissolve the pigments. Another advantage of using a workable fixative is that once

add more oil in the shaded areas and slightly blend it into the buffed area. You can now use another color as an accent to add contrast.

Using Pastels on Digital Prints

You can also achieve the look of a hand-tinted photograph by applying oil pastels to a computer-generated digital print. Oil pastels are oil paints that have been thickened with binders and formed into easy-to-handle sticks. They are not the same as the soft chalk pastels used for drawing, which don't stick as well as oil pastels.

it dries you can apply another layer of color to your print, without disturbing the first layer. After applying the fixative, use a clear acrylic sealer, such as Krylon Crystal Clear, to finish your prints. This spray has a luster finish that will slightly enhance the colors and prevent fading.

Digital Tinting

Achieving a tinted effect with a digital print can also be done digitally in several different ways by using Adobe Photoshop or other similar image editing software. The easiest method is to start with a RGB color digital image, go to Image-Adjust-Hue/Saturation, and slide the saturation scale down to desaturate the color on your image until it has the appearance of a hand-tinted photograph.

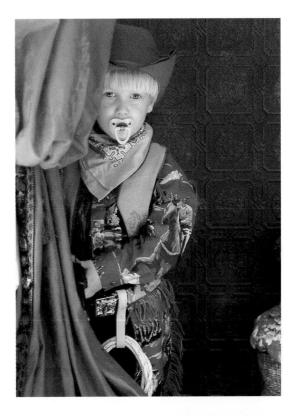

Glossary

Aperture

The opening within a lens that allows light to pass through to the film. Its size is measured in f-numbers (f-stops): a higher number indicates less light passing through than a lower number.

APS (Advanced Photo System)

APS cameras use a smaller film than traditional 35 mm but offer several unique features (see pages 43–44).

Auto-Exposure

A camera feature that senses the amount of light in a scene and adjusts the shutter speed and/or aperture accordingly, for the optimum exposure. AE accuracy can vary with the quality of the camera's internal metering system. The combination of auto-exposure and auto-focus are what make a point-and-shoot camera what it is. Automatic exposure modes include aperture-preferred, shutter-preferred, and programmed.

Auto-Flash

A feature that automatically determines when the camera uses its built-in flash.

Auto-Focus

A camera feature that senses the distance to the subject and automatically adjusts the focus of the lens. Some cameras even have a "predictive" focusing system that determines the optimum focus on a moving subject at the precise time of exposure—great for photographing active children.

Automatic Film Loading

Cameras with this feature allow you to place the film in the camera and then let the camera automatically wind the film into start position. Some cameras load more easily than others. Look for one that winds the film roll completely out of the film cassette and rewinds the film back into it after every shot. That way, if your camera is accidentally opened mid-roll, the pictures you have taken are safely stored in the canister.

Backlighting Compensation

A very useful camera feature allowing the photographer (or the camera) to compensate for strong backlighting, in order to prevent accidental underexposure—for instance, when photographing a subject in front of a brightly lit window.

Bounce Flash

The technique of bouncing an electronic flash off a wall or ceiling. This softens the light on your subject, but it requires using a separate flash unit rather than the one built into your camera.

Built-in Flash

A flash unit permanently mounted on your camera.

Camera Shake

A blurring effect caused by camera movement when and holding the camera. It is often made worse by using a longer telephoto lens or a slower film speed.

Captions (Day/Date)

The day and date you exposed the image, printed either on the front or back of the print or directly onto the negative. This can be a great record-keeping feature or, when printed on the front of your pictures, a big distraction.

Continuous-Wind Mode

Lets the camera fire frame after frame when you keep the shutter-release button depressed. Great for capturing fast action, but it can use up a lot of film very quickly.

Depth of Field

The apparent depth of focus in front of and behind your subject. Technically, there is only one point in exact focus at any time. When you "stop down," or use a high f-stop, points in front of and behind the actual point of focus appear in focus but are not actually in sharp focus. This range is referred to as the "depth of field."

Digital Camera

A camera that exposes light to a charge-coupled device (CCD) as opposed to traditional silver-based film. Prints are made through a computer to a digital printer.

Directional Light

Light coming from an identifiable direction, such as a door or window. The opposite of "flat lighting," which has no directional quality—outside on an overcast day, for example.

DX Code

The camera needs the film's ISO speed in order to know how to expose it when the camera is set for auto-exposure mode. DX encoding allows the camera to read the ISO speed of the film. This means the user can't forget to tell the camera the speed or perhaps tell it the wrong speed.

EV Compensation

This feature, found on better automatic cameras, allows you to temporarily change the ISO setting on your camera up or down to intentionally over- or underexpose your film.

Fill Light

Light that fills in the shadow side of a subject's face, for instance, to prevent it from becoming too dark.

Fill-Flash Mode

Manually or automatically uses the camera's flash to provide fill light. Some better cameras have very sophisticated systems to calculate the flash intensity.

Film Speed

A film's sensitivity to light, measured in ISO numbers. A lower speed is less sensitive to light than a higher-speed film and is said to be "slower."

Filter Pack

A group of color filters in a paper printer that allows the operator to control the color balance of your photographs.

Focal Length

A number quantifying the degree of magnification of a lens. A higher number (100 mm or more) designates a telephoto lens, which brings objects closer. A lower number (35 mm or less) designates wide-angle lenses.

F-Stop

A measurement (based on mathematical principles you don't ever have to learn) indicating how much light the lens is letting pass through its aperture onto the film.

Grain

A characteristic of film that results from the silver halide particles making up the image on it. Grain becomes more apparent with enlargements and when using faster films.

Hot Shoe

A receptacle on a camera that allows you to mount a separate flash unit.

ISO Number

An internationally recognized standard for rating a film's sensitivity. (ISO is an abbreviation for International Organization for Standardization).

LCD Panel

A display panel that, when done right, is full of easy-to-read and useful information about the current status of your camera. (LCD is an acronym for liquid crystal display.)

Macro Mode

Feature allowing very tight close-ups. Rated in inches from the subject to the film plane.

Metering Modes

Different modes of auto-exposure designed for various common shooting situations.

Motor Drive

The motor in the camera that advances your film. Some do so much more quickly and quietly than others.

Overexposure

The result of more light reaching the film than is required for proper exposure.

Owner's Manual

That little booklet you know you should read but just can't make yourself take the time to study. Shame!

Panorama

A feature on APS cameras allowing you to take a picture that will come back as a 4 x 10 in. print. The same effect can be achieved by ordering an 8 x 10 in. print from a 35 mm negative and trimming it to size—as long as you composed a shot that makes sense in that format.

Parallax Error

On a non-SLR camera, the difference between the field of view seen through the viewfinder and what the film actually registers through the lens. This becomes a problem only when taking close-up pictures.

PC Cord

A cord attaching a camera to an electronic flash. They are fragile, so always have a backup.

Point-and-Shoot Camera

An easy to use, fully automated camera that allows you to simply load, point, and shoot to create a photograph. Some modern point-and-shoot cameras are far more sophisticated and versatile than others.

Red-Eye Reduction Mode

One of a few different automatic features designed to eliminate, or at least diminish, the effect of glowing red eyes in photos taken with built-in flash.

Self-Timer

Allows you to run around and get into your own picture several seconds after the shutter-release button is pressed. Also an effective tool for making a rock-steady exposure from a tripod.

Shutter Release

The button you push to trip the shutter and take a picture.

Shutter Speed

The amount of time (measured in fractions of seconds) the camera's shutter remains open to allow light to pass through to the film. Sophisticated cameras have a much wider range of shutter speeds to choose from than do more modest models.

SLR (Single-Lens Reflex Camera)

In these cameras a series of mirrors allows you to see right through the actual lens to view exactly what the film will register, eliminating parallax error.

Sync Speed

Maximum shutter speed at which the camera can take a flash picture. Using a slower speed than the maximum can provide a much better picture in certain situations. Never use a higher speed than the maximum sync speed listed for your particular camera, because the lens will close before the flash is through firing.

Telephoto Lens

Longer-focal-length lenses designed to bring distant objects closer. Great for portraits but slower and harder to hand hold.

TTL Operation

"Through the lens" flash operation senses the amount of light passing through the lens and relays it to the flash for more accurate exposures. Only flash units that are "dedicated" to a particular camera will operate this way (a dedicated flash is one designed to communicate with a specific camera).

Underexposure

The result of less light reaching the film than is required for proper exposure.

Viewfinder

The part of the camera you look through to see the image.

Wide-angle Lens

A short-focal-length lens designed for a wide field of view. It can create distortion when used in close-ups.

Zoom Lens

Allows you to move toward or away from your subject by just changing the lens's focal length rather than by walking (or, in the case of photographing kids, by crawling).

Useful Websites

Film Companies

Kodak
www.kodak.com
At the time of this writing this is the most well-thought-out and organized photography site we have found, with hundreds of sample photos. It does a wonderful job of explaining film, exposure, and picture-taking skills in an easy-to-read manner that does not make you feel as though someone is trying to sell you something. It also goes into film and print storage, APS, album creation, the latest digital technology, and more.

Fuji
www.home.fujifilm.com
This site is a little harder to navigate than the Kodak site but it offers a wealth of photographic information.

Agfa
www.agfa.com
Not quite as informative as those by the other two major film manufacturers, but worth a look.

Camera Companies

Canon
www.usa.canon.com/productline.html
This address bypasses all the other Canon merchandise and takes you right to their camera information.

Nikon
www.nikonusa.com

Minolta
www.minoltausa.com

Pentax
www.pentax.com/home.html

Olympus
www.olympusamerica.com/
 featurefoc.asp?s=12&featurefoc=12
This takes you directly to the Olympus photographic equipment.

Polaroid
www.polaroid.com

Other Useful Sites

Lisa Jane Wedelich
www.lisajane.com

Rick Staudt
www.rickstaudt.com

Professional Photographers of America
www.ppa-world.org
A great sampling of professional photography to inspire you, and the site to visit if you are interested in doing this professionally. PPA is the world's leading organization for professional portrait photographers.

Outdoor Photography Magazine
www.outdoorphotographer.com

Apogee Photo Magazine
www.apogeephoto.com
An established on-line photo magazine with lots of excellent photographs and articles.

You might also want to try simply typing "children's photography" into your favorite internet search engine and see what you get. One thing you will find are listings of portrait studios from all over the world. Look at their sites to discover the latest trends in children's portraiture and to get inspiration in general.

Index

Editor: Nancy Grubb
Production Manager: Louise Kurtz
Front Cover Design: Paula Winicur

First edition
10 9 8 7 6 5 4 3 2 1

Library of Congress Cataloging-in-Publication Data
Jane, Lisa.
How to photograph children : secrets for capturing
childhood's magic moments/Lisa Jane, Rick Staudt.
 p. cm.
ISBN 0-7892-0652-8
1. Photography of children. I. Staudt, Rick. II. Title.

TR681.C5J38 2000
778.9'25—dc21
00-36250